PAINTING PORTRAITS IN WATERCOLOUR

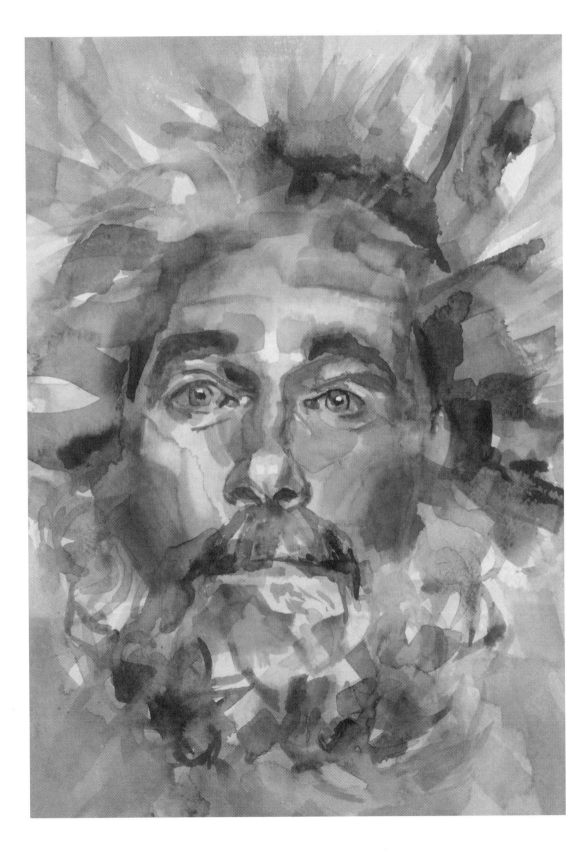

LIZ
CHADERTON

PAINTING PORTRAITS IN WATERCOLOUR

THE CROWOOD PRESS

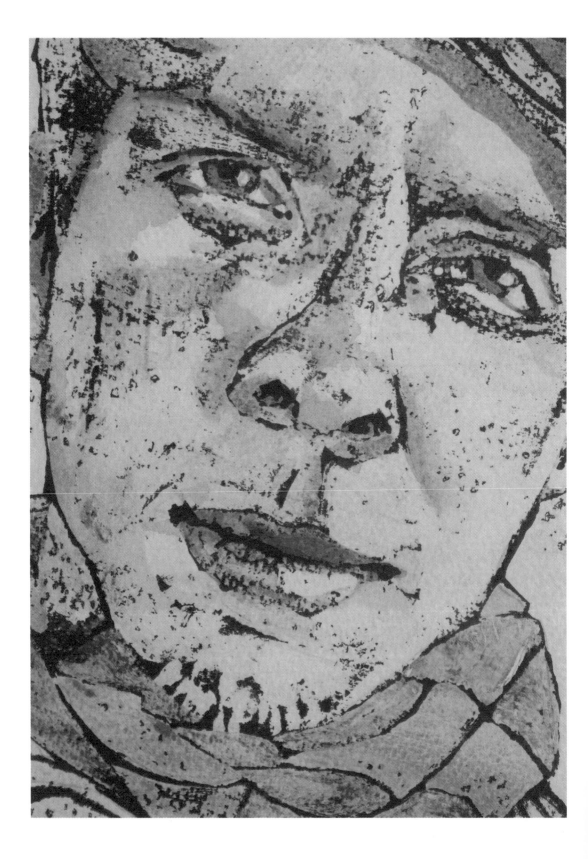

CONTENTS

Introduction 7

1 Transferring Your Image 9

2 Getting to Grips with Tone 19

3 Playing Around with Colour 31

4 Layering Colour 43

5 Line and Wash Portraits 57

6 Watercolour Plus – Mixed Media 69

7 Special Challenges and How to Tackle Them 83

8 Achieving a Likeness When Drawing Portraits 97

Further Resources 108

Index 110

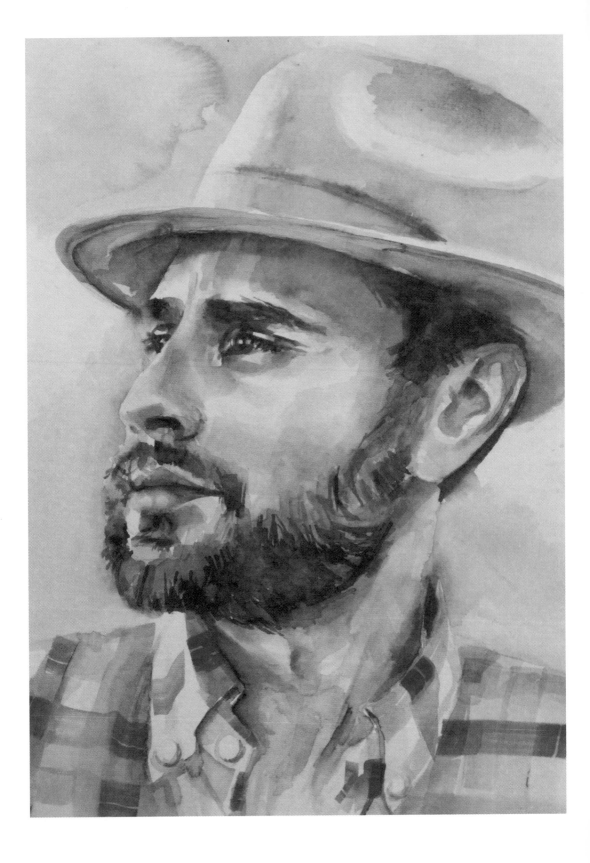

INTRODUCTION

What makes a great portrait? We are hardwired from birth to find human faces fascinating, so it is hardly surprising that we want to capture them through painting. Yet portraiture is considered one of the most challenging subjects. We expect a portrait to look like the person; 'sort of' is not usually acceptable and so many artists shy away from even attempting them. Beyond achieving a likeness, a great portrait gives the viewer a glimpse into the subject's inner life. There is also a strong argument that every good portrait is really a self-portrait. Your painting will capture a bit of your character, even when you are not the subject.

The paintings in this book are not portraits to hang in museums, but to celebrate the everyday faces and characters of family and friends. I believe that if you can paint a landscape, you can paint a face; if you can capture your pet's likeness, you can paint a person. Using techniques from still life, urban sketching and landscape painting, we will apply them to faces in a fun, contemporary and joyful way.

Why watercolour? At its best, it is a light-filled, dynamic medium. This spontaneity makes it ideal to capture the life and energy of your subject. While you may think of watercolour as delicate and ethereal, it can be bold and dynamic. Such versatility allows us to capture the essence of a wide range of sitters, so muses of all ages, sexes and races will inspire us throughout this book. For me, the medium is at its strongest when it is loose and gestural rather than overworked; letting the watercolour do what it wants to do brings out the best.

Drawing a likeness and painting a lively portrait are two different skill sets. Because we are gripped by faces, our brains tell us we already know what they look like and gets in the way of us really seeing what is going on. Many artists become despondent because they spend so much time trying to achieve a likeness that all the joy is sucked out of the process.

This book turns the usual order upside down and starts with painting technique, initially using transfer methods to map the contours of the face onto paper. Only once confidence is high do we tackle achieving a likeness freehand.

Building on the tonal map of the face, we will develop realistic layered portraits and more impressionistic renditions. Covering both pure watercolour and line and wash, this book also explores mixed media and specific challenges. Some knowledge of watercolour is assumed, but materials and techniques are explained as we progress.

At the close, the reader should have the confidence and skills to produce lively contemporary portraits, full of life and energy, and be ready to celebrate and capture the human face in all its glory.

Watercolour is such a versatile medium to either render a subject in detail or through flowing washes.

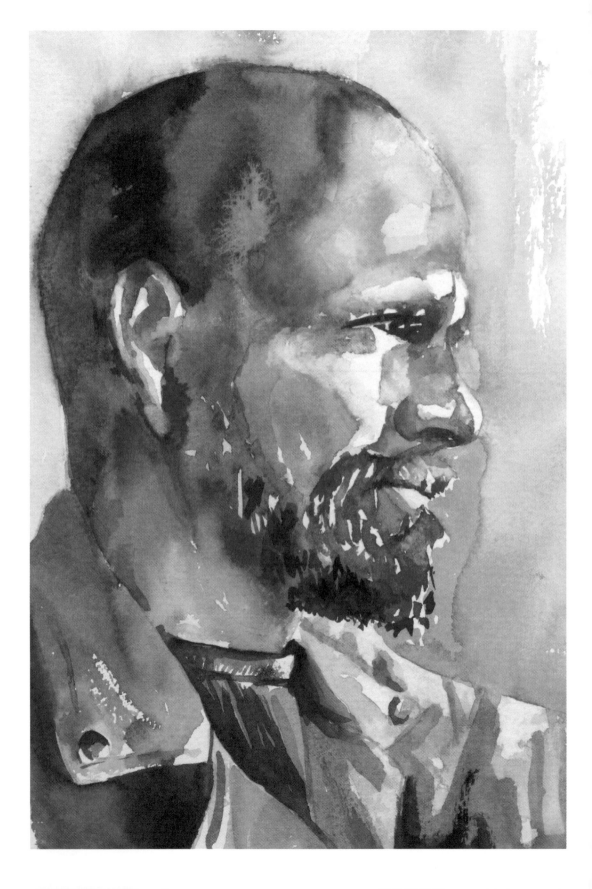

TRANSFERRING YOUR IMAGE

DON'T STRESS ABOUT THE DRAWING

The skills used to draw a likeness and the skills used to paint a lively portrait are different. Both are complex skill sets, but they are not one and the same. Many portrait books start with how to draw the face, perfect proportions, features and so on. This can trip people up and they fall at the first hurdle. By the time they have obtained a likeness on paper, the surface is scuffed with rubbing out and the artist is near despair.

There is no getting away from the fact that being able to capture a likeness takes practice. But why don't we turn things on their head? Let's learn the painting skills first. By doing so we will build experience and confidence and become familiar with features and how they relate. Along the way we will train our eyes and brain to see what is going on.

Success breeds motivation. For this reason, I strongly urge you to use one of the transfer methods described here to gain the outlines and proportions you need.

ISN'T THAT CHEATING?

There is often the feeling that if you are not drawing freehand from life, you are somehow cheating, or that any painting produced using

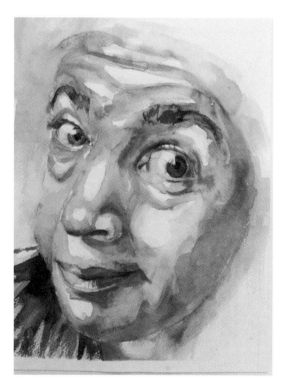

The underdrawing for this portrait was done freehand, which does not make it a better or worse painting.

drawing aids must be inherently inferior to those produced without them. Some people go so far as to say that you shouldn't even do a preparatory underdrawing, and that painting directly with no pencil guidelines is better than painting with them. Others worry that if they use some sort of tracing or transfer method,

Using a transfer method rather than drawing freehand doesn't have to result in a stilted painting.

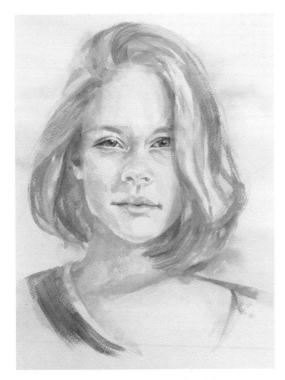

The same face, traced each time can look so different.

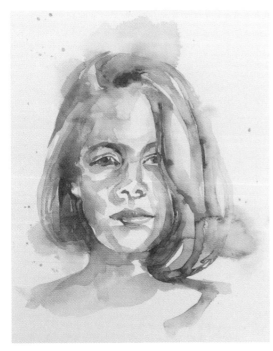

You can use all your painting skills to interpret the same outline in different ways.

their paintings will be devoid of life and character. Banish these thoughts.

Art historians tell us Vermeer used a camera obscura – does that make the *Girl with the Pearl Earring* any less wonderful? Joshua Reynolds' camera obscura is in the Science Museum, London. Throughout history artists have used tools at their disposal to help them get their vision onto paper or canvas. Apply the logic described in the previous paragraph to another context and you will see the flaw. If you go somewhere by car is that cheating – shouldn't you walk? Tracing or transferring is just a tool to get you to your destination in an efficient way.

If a room full of artists were to trace a reference photo, then paint it using the same colour palette and tools, each painting would be different. A portrait often says more about the character of the artist than it does about the personality of the sitter. This is not to say that you should not work on your drawing skills, however, because drawing is far more than simply getting accurate guidelines down on paper.

Fired up with the success of painting lively portraits, you will be far more positive about putting in the work to capture a likeness. At the end of this chapter, I suggest some drawing exercises. Five or ten minutes spent on them daily will start to develop new pathways in your brain and better hand-eye coordination. When you decide you are ready to draw a likeness freehand, you will be in a strong position.

WHICH LINES TO TRANSFER

Aim to transfer as few lines as possible, but enough detail to guide you on the placement of features. You do not want so many that you are tempted to 'colour in'. I would suggest the outline of the face and features, distinct highlights that must be retained and the mass of hair. Smaller details will confuse you. If you

transfer too many details, remove them before starting to paint. Keep lines as light as possible. The pencil lines in this book are darker to show clearly in photos. You could use a watercolour pencil if you like and this will dissolve into your washes.

HOW TO TRANSFER YOUR PHOTO

Projecting or tracing your work onto your watercolour paper has the distinct advantage of being rapid and ensures that the surface of the paper is not damaged with rubbings out. Even artists sketching from life often draw on one piece of paper and use a transfer method before painting to avoid damaging their final paper.

Each method has its pros and cons.

Direct Transfer

Print out your chosen reference and turn it face down. Use a soft (for example 2B) pencil. Scribble densely all over the reverse of the image. Now flip over and use a piece of masking tape to affix it to your chosen painting paper. Using a pencil or stylus, press firmly and draw over the lines you wish to transfer. Check that the line is showing sufficiently and adjust your pressure. While you can use a pencil, to avoid obscuring the photo which you still need, use an old ballpoint pen, a glass dip pen (without the ink, obviously) or another blunt but pointed firm implement. When you have transferred enough lines, remove the printed photo.

The downside of this method is that you cannot increase or decrease the size. Also, you need to be able to print your image and you will mark the print in the process. It is, however, the easiest and most direct method.

Tracing

Using tracing paper (or improvising with baking parchment) is also straightforward. It will not damage your reference photo, but you cannot

increase or decrease the size of your image. The other downside is that you have to press firmly with a pencil to transfer the image, which can leave grooves in your paper, but the original remains unmarked.

Simply place the tracing paper over the photo, hold it in place so it doesn't slip and mark the lines you require. Remove and flip the tracing paper over. Scribble over the lines with a soft pencil and then place on top of your painting paper. As before, go over the lines using a pencil or stylus and check that you are pressing hard enough to transfer, but not so hard as to groove the paper.

Carbon/Graphite Paper

For an exact size copy of your image, graphite paper is slightly quicker to use than tracing paper. The sheets are reusable. Avoid ordinary carbon paper, as the line can be waxy and resist your paint; graphite paper is a better option. Place it graphite-side down on your painting paper. Place the printed image on top and again go over all the required lines using a pencil or stylus, checking that your pressure is sufficient to transfer a visible line.

Gridding

Gridding not only allows you to increase or decrease the size of your image, it also has the advantage of engaging your drawing muscles more than some of the other methods. It can be rather tedious.

You must first ensure that the dimensions of your paper are in the same proportion as your source photo. Do this by lining up the corner of your photo and your paper, and put a ruler through the diagonal corners. Where it hits the far edge indicates the dimension of your destination paper.

Now grid your reference photo. Depending on the size of your photo, you may wish to draw squares of 1cm (⅓in) – the smaller the boxes the more detailed the transfer. The more accurate you are at this stage, the better the outcome. Free

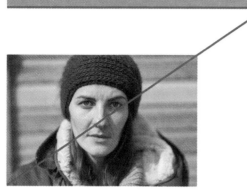

If the reference and drawing surface are not in the same proportion you will distort the image.

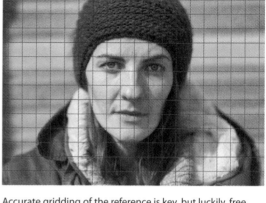

Accurate gridding of the reference is key, but luckily, free online tools are available.

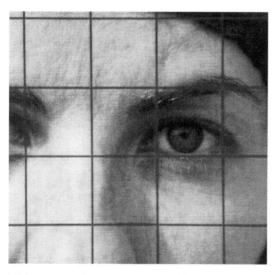

It is important to be as accurate as possible.

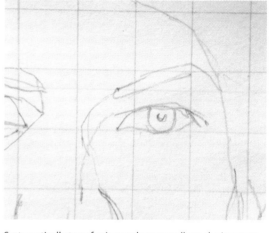

Systematically transferring each square allows the image to be increased (or decreased) in size.

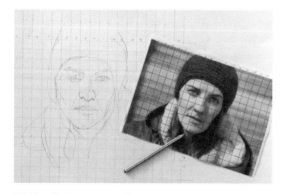

Gridding helps tone your drawing muscles as you are still observing and judging.

gridding apps are available and are precise and quick to use (*see* Further Resources for links).

Next divide your destination paper into the same number of squares. Draw these grid lines lightly so they will be easy to erase or they will show in your final piece. An alternative is to use a watercolour pencil. If you choose a toning colour, the lines will melt away into your washes and not show in the final piece.

Transfer the source image to your destination square by square. If a line runs diagonally through the small square on the photo, place it diagonally through the large square on your paper. When finished, erase the grid.

This can be a slow process but it should be 100 per cent accurate and is ideal if you need to increase the size of your image.

Simplified Gridding

For those who are more confident in their drawing skills but who still need some support, a simplified grid can be useful. Rather than gridding with squares, divide your reference into equal quarters with a horizontal and vertical line, and then draw in diagonals. Do the same with your paper, ensuring that the proportions of reference and final paper are the same. Now use the eight triangles to transfer your image in a similar way to the more complete gridding system.

Interestingly, a version of this type of grid can be seen in the Van Gogh Museum in Amsterdam, showing how Vincent van Gogh used it in his paintings.

Window or Computer Screen

On a bright day you can use a window as an impromptu light box. As long as your watercolour paper is not too thick (300gsm/140lb), you can tape the photo to the back of your paper to avoid movement, then place it on a bright window. You should be able to see through the paper sufficiently to trace the outline, especially if the room you are in is dimly lit. You cannot alter the size of your piece.

Alternatively, use a computer screen or tablet. First disable any touchscreen facility (look in your settings to do this). Turn up the screen brightness to its maximum. Tape your photo to the back of your watercolour paper and trace the image. You can increase or decrease the size of the image on the computer or tablet. Turn off lights in the room to make it easier to see the backlit image.

Light Box

A4 or A3 LED light pads are readily available at a reasonable price. They are designed for craft applications and usually plug into a USB port. Though dimmer than more expensive art light boxes, if used in a room with low ambient light, the image is readily visible through 300gsm/140lb paper. They are quick and convenient to use. These are my preference.

Tracing Apps

Paid-for drawing apps are available on your tablet or smartphone. These superimpose the image you wish to copy onto your surface by using the device's front and rear cameras. They often have photo manipulation software built in. You will need a tripod or similar to keep the device in place. Within limits you can increase or reduce the size of the image depending on how far it is positioned from your paper. The downside is that they take some getting used to.

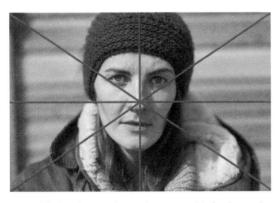

A simplified grid is speedier and more suitable for those who are already confident in their drawing skills.

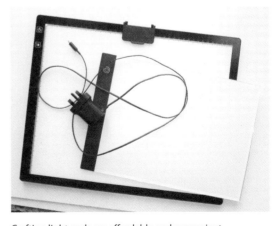

Crafting light pads are affordable and convenient.

Projectors

You can use a projector to enlarge drawings and project them onto your work surface, where they can be easily traced. They often project from a horizontal surface to a vertical one. Projectors are also handy for mural painting, video art and showing your portfolio.

They fall into two categories – opaque and digital. An opaque projector shines light through your printed image, so the room you are working in needs to be dim. A digital one is more expensive but will project an image from a computer, phone or tablet and is versatile. You may wish to consider the portability and ease of use of a projector, and unless you are planning to regularly enlarge images by a factor of ten, they are unlikely to be worth the expense.

REMOVE UNWANTED GRAPHITE

Once you have transferred your image, check that the lines are not too dark as you probably will not want them to show through the final painting. The easiest way to do this is to roll a kneaded eraser into a sausage and roll it backwards and forwards across the drawing to pick up excess graphite. Use soft white bread without crusts if you need to improvise.

WHAT TO LOOK FOR IN A GOOD REFERENCE PHOTO AND WHERE TO FIND THEM

A good reference photo is something very different from a good photo, but the most important thing is that you are excited to paint it! If it doesn't motivate you, you will have to work hard in your painting. Interesting angles and unusual expressions may be fun. Look for a photo that makes your life easier and does not fight you.

You need lots of information like shape and value in a reference photo. Dramatic light may

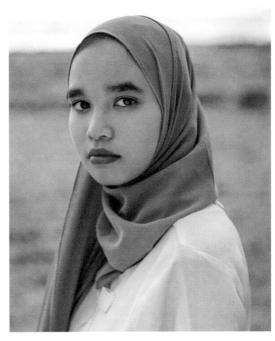

A good reference photo should be in focus, have directional lighting, have a good range of tones and above all excite you to paint it.

be fun to work with, but an underexposed or overexposed photo may be short of tonal information. If it is overexposed, the information in the light areas may be missing, and if underexposed, the information in the shadows is lacking.

Non-directional light can make it hard to see shadows and form, though flat lighting can smooth out wrinkles and flatter the subject. Photos with an obvious light source and a good sense of light and dark are much better to learn from, as you can see the volumes.

Photos need to be a good size, in focus and high resolution. A blurry group snap is not suitable for a portrait. Beware that with selfies, the camera is so close it will distort the face; this can be fun or a curse.

Many royalty-free websites such as PaintMyPhoto, Pixabay and Sktchy have excellent photos to practise from (*see* details in Further Resources). The issue with using

publicly available photos is that other people may also use them and that they tend to be of rather beautiful people in perfect poses. For more interesting characters you will have to look harder or take your own images.

PHOTO REFERENCES IN THIS BOOK

Throughout this book, photos have been chosen from Pixabay and links given in Further Resources. Different ages, sexes and races have been chosen to give as wide a range of the human face in all its glory as possible. Please note that while these photos were available at the time of writing, the photographers can remove them at any time, so if you find they are no longer available you will have to search for similar.

DRAWING SKILLS EXERCISE

Although we are using transfer methods, it makes sense to start training your drawing muscles now, so that by the time you get to Chapter 8 they are toned and strong. Practising

Holding your instrument in a different way transforms the quality of your line.

THE PERFECT REFERENCE

- You want to paint it
- Neither overexposed nor underexposed
- In focus
- Balanced between bounced light and direct light, that is, well lit
- Large enough to see sufficient details
- Be aware of distortions
- Natural and relaxed pose

for ten minutes each day makes a huge difference over the course of a month. Don't worry about using a face – just choose a nearby object. These exercises can also be great as warm-up exercises to help you get to know your subject, so consider trying them before any of the step-by-step examples throughout this book.

The aim is to train your ability to observe and develop your hand-eye coordination, confidence and experience.

Change Your Grip

Choose a simple object, paper and any drawing implement. Now draw it in your normal style. Look at how you are holding the pen or

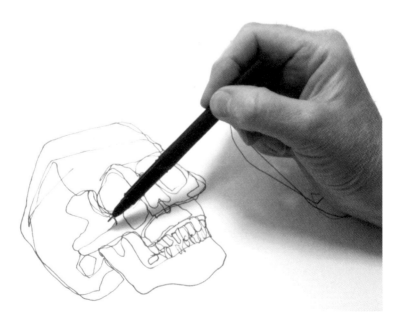

pencil – it's probably with the same grip you use to write. Repeat, but move your hand further up the barrel. You will lose some control but you will have a lot more movement and be capable of more flowing lines. Now try the same with an overhand grip. It may feel odd, but you will probably use more of your arm and draw from the shoulder rather than the fingers.

Continuous Line
The idea is to train your eye to look at an object and flow around it in harmony with your hand.

You will be keeping your pen or pencil on the paper at all times, so choose an implement that will not run out (not a dip pen). Choose any object and any surface and then draw it, keeping the contact with the paper. If you need to repeat and go over lines or open spaces, so be it.

Non-Dominant Hand
Even if you are very left-handed or very right-handed, you can draw with your other hand. It will make you look at your subject and really concentrate on the process. It will also use a

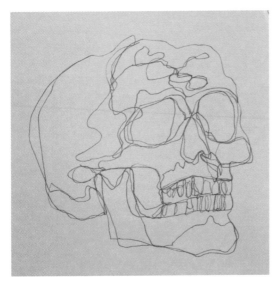

A continuous line drawing can be energetic and fast.

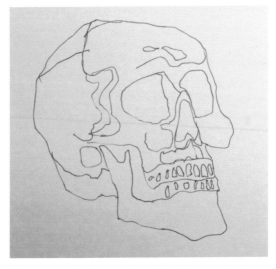

What you sacrifice in control you will gain in concentration when you use your non-dominant hand.

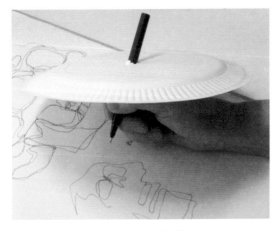

A simple paper plate with a hole in it will prevent any temptation to peek.

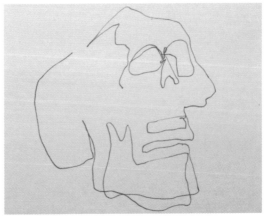

The results of blind drawing can be comical or surprising, but en route you will improve your hand-eye coordination.

different hemisphere of your brain; all your neural pathways will be strengthened. Simply select an object and have a go at drawing it with the wrong hand. You will sacrifice fine-motor control, but you may be pleasantly surprised at the outcome.

Blind Drawing

Hand-eye coordination is a must; aim to spend more time looking at your subject than your paper. To stop you cheating in this exercise, get a piece of card or a paper plate and put a hole in it. Put your pencil through and hold it below the plate. Now choose a simple object and draw it without being able to see your drawing. You can use a continuous line or take your pencil/pen off the paper. You are not allowed to look to see where to put it back down. Once you are finished, take a look. Is it disjointed? Or is one side better than the other? Keep going until you become more confident.

Timed Drawing

Set the clock for ten, fifteen or twenty minutes and draw your object in whatever method you choose. The limited time forces you to get to the essence of the subject, to simplify shapes and tones and to be decisive. It can be amazing what you achieve in such a short time.

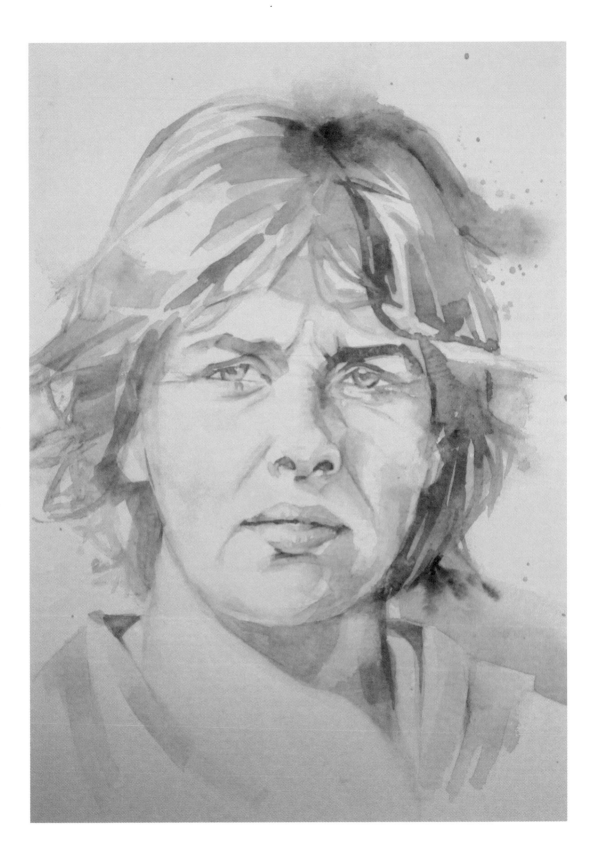

GETTING TO GRIPS WITH TONE

There is an art phrase I love: 'Tone does all the work and colour gets all the glory'. Nowhere is this truer than in the world of watercolour. While people will comment about a picture's stunning colours, it is the range of tones, from the sparkling white of untouched paper to the dark of full-strength paint, that captures a sense of volume on the flat surface. Every strong painting is based on the balance and range of tones, so when tackling a new subject, using a single colour (monochrome) is a fabulous way of letting you concentrate without worrying about colour mixing.

MATERIALS

Most portraits in this book will not take much longer than an hour to complete, depending on how fast you work. They are not designed to be laboured over for days. I am working on Bockingford 300gsm/140lb NOT/cold-pressed watercolour paper throughout, using quarter sheets (38 × 28cm (15 × 11in)). Each portrait is therefore slightly larger than A4 – A4 being approximately 21 × 30cm (8 ×12in).

Materials will be mentioned as they are introduced. Please do not skimp on paper, as it is the most important part of your equipment in watercolour. Saving good paper for 'best' is a false economy.

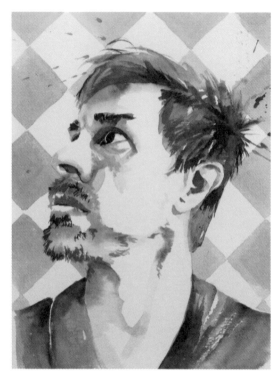

A background can help a monochrome portrait have real impact.

Tube, artist-quality colours are used in general, but you can of course use pans and student-quality paint, if that is what you have. Improvise with colours and do not be too hasty to buy a whole new set for this book.

Three brushes should see you through – a round (12– 14), a medium round (7–8) and a

A single colour portrait allows us to concentrate on tone without worrying about colour mixing.

rigger (2). A flat brush can be fun for creating a high-energy, choppy portrait.

WATERCOLOUR TECHNIQUES

At its heart, watercolour is very simple. Essentially, one can have wet paper or dry paper, and wet paint or dry paint. There are four different combinations of these factors, which leads us to wet on dry, wet in wet, and dry brushing. How we combine these techniques to create beautiful paintings is the challenge that takes a lifetime to master.

PRACTISING TONE

In watercolour, we alter the tone of our mix by adjusting the pigment-to-water ratio. We do not have the luxury of adding white to lighten the tone or black to darken it. To add a slight complication, we might have water on our paper or in our brush, which will alter the mix further,

so being aware and in control of the paint/water proportions is a key skill.

Try This

Choose a colour that is dark in its strongest form – one that is said to have a 'dark mass tone'. Intrinsically, yellows and pinks are light colours; even at full strength they are only midtones, so choose a colour that is capable of being dark.

On a strip of watercolour paper (cut up old paintings and use the back), mark out seven to nine squares. Add just enough water to your paint to get it flowing and paint the first square; this is your darkest tone. Now add a little water and paint the next. It should be perceptibly lighter, but only by one step. Continue in this way, aiming to end up with just a tint of colour.

It is trickier than you think to get that nice, even graduation. If you stay dark too long or get light too quickly, have another go until you have eight evenly spaced tones. Save these swatches as we will use them in Chapter 3.

Watercolour does not have to be complicated. The simple combination of paint, paper and water leads us to infinite possibilities.

Being able to adjust the paint-to-water ratio at will to achieve the perfect tone is a key skill.

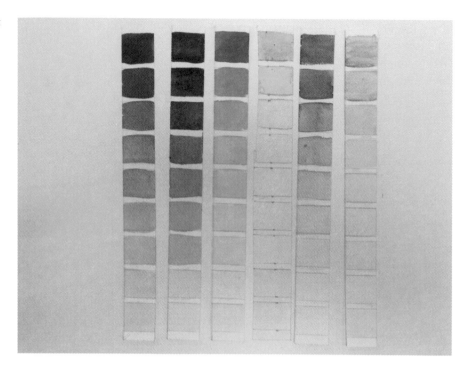

EDGES

The quality and variety of your edges makes an enormous difference to the final painting. In watercolour, we talk about soft and hard edges, alongside lost and found. Each has a role to play, and by varying the balance of each in a painting, you will alter the mood of the piece. Most people do not fully appreciate the importance of edges; colour and composition usually hog the spotlight.

At the risk of stating the obvious, an edge in art is the transition between two areas of tone or colour. Hard edges indicate a distinct change from one colour shape to another. In watercolour, we achieve them by working on dry paper, also called the wet-on-dry technique (1).

Soft edges indicate a gradual or smooth transition. We can achieve them in different ways. If an edge has dried, it can be reactivated and blended by using a damp brush (a small flat brush is a good tool to use here). Some colours are easier to soften than others. In part (2) of the

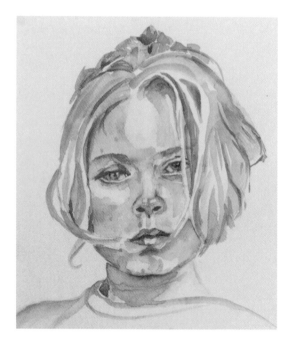

Certain colours have a 'light mass tone', so achieving a strong portrait will be a struggle. I had to cheat by adding some Burnt Sienna to the deeper tones in this yellow portrait.

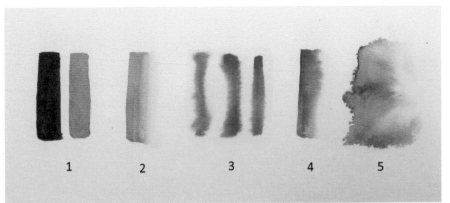

Edges play a huge role in the success of your painting.

1	2	3	4	5

example, the edge is hard to soften as the purple is a staining colour. Working on wet or damp paper will give a soft edge. Just how soft it is will be in proportion to the wetness of the paper (3). Alternatively, we can create a hard edge on dry paper and use a wet or damp brush to soften it before it dries (4).

Lost edges are so soft you cannot actually see them (but you know an edge is there based on other elements). They can be created in the same way as soft edges. A small, fine spray bottle can be a lovely way of losing an edge (5). A found edge is another name for a hard edge, usually in relation to lost edges nearby.

Why Edges Matter

Edges can provide an incredible amount of information about a subject. They also create an overall mood for a piece. They can tell you how important the object is in the composition; if the object is in focus or in the background; or how far away the object is. Hard edges attract attention, so are often placed at the centre of interest. However too many hard edges can be jarring and look naïve.

Soft edges can tell the viewer that the object is not that important; they can create a dreamy atmosphere and can be very calming. Used to excess, the painting may be hard to read and lack impact. Lost edges can create a pleasing mystery and looseness in a painting. Used to excess, the painting can lose all focus.

TONAL PERCEPTION

We judge the light or dark of a colour by contrast. The same tone will look darker if it is next to a light colour and lighter if next to a dark one. Many optical illusions rely on this phenomenon. Look at the four smaller grey squares below and ask which is darker? They are the same tone, but their surrounds easily fool our brains. You can use this to your advantage when painting.

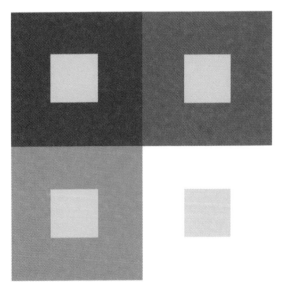

We judge tone in contrast to the surrounding areas, so a light surround will make a tone appear deeper and vice versa.

Top Tip

People often struggle with the concept that even if the local colour of an object is dark – for example with black hair – there will be very light tones within it, such as the highlights on shiny hair. If you find it hard to see tones, use your computer or phone to turn the picture into a black and white version and work from that. You can do the same to check the tonal balance of your painting. It will really help show up any problem areas. Of course, the old-fashioned way is to squint!

You can also cut a small square out of a piece of paper and use this to compare tones. You will then be comparing like with like.

If you are struggling to compare tones, cut a window in a white piece of paper and use this to view. You are now comparing like with like.

POSTERIZE

Most photo-editing software has a useful setting called 'posterize'. This clumps together areas of similar tone in a black and white

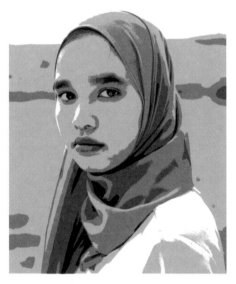

The posterize function on your phone or computer will be invaluable. Here it clumps tones together.

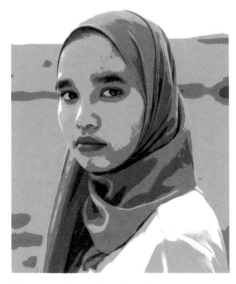

If you posterize a colour photo, it groups similar colours together, which will really help train your eye.

photo or similar colours in a colour photo. It almost turns the photo into a stencil. It is worth exploring this function in whichever software you use (even the edit function on your phone), as it will help you train your eye and really support your painting in the meantime.

WATERCOLOUR PAPER – WHAT TO LOOK FOR

The quality of your paper impacts your work far more than the quality of your brushes or paints. Do not be tempted to save your decent paper for 'best'. Practising on poor paper is simply dispiriting; you will not be able to attain the effects other artists achieve regardless of your skills. Instead, find a good-quality paper that will not break the bank. Buying it in sheets and cutting to size will make your money go further. Having a plentiful supply will give you the confidence to experiment.

Good watercolour paper is acid-free, so it will not yellow with time. It is sized to control the rate of absorption. Unsized paper acts like blotting paper, whereas hard-sized paper is not very absorbent at all. Each suits a different style of working, so try different ones until you find one you like and can afford. Some retailers sell sample packs of different papers.

As noted earlier, all paintings in this book are done on unstretched quarter sheets (38 × 28cm (15 × 11in)) of 300gsm/140lb NOT-surface (cold-pressed) Bockingford (a cellulose paper). Let me explain what these terms mean.

Watercolour paper is either made of cotton or wood. Cotton has longer fibres and is stronger and often more resilient. It will take more layers of colour and potentially hold more water without pilling. Both types can be archival, that is, they will not become brittle or yellow with time.

A standard Imperial sheet of paper is 76 × 56cm (30 × 22in). They are sold in half sheets and quarter sheets. Pads are available in many sizes and are glued or spiralbound.

The weight or thickness of the paper is measured in pounds per ream (500 sheets) or grams per square metre. Thinner paper is cheaper but will cockle (go wavy) if a lot of water is used. It may need to be stretched. Thicker paper is more expensive but will give you more working time because it absorbs more water. A 300gsm/140lb paper, especially in smaller sizes, should not cockle badly.

Three different surface textures are generally available – hot pressed, NOT (also called cold pressed) and rough. Hot is smooth, rough is rough and NOT is in the middle. I suggest NOT as it allows good control of the water without an obtrusive texture.

TONAL PORTRAIT

We are trying to treat the face as a landscape of hills and valleys and create a tonal map of the subject.

Starting with a light wash and retaining the lightest areas as white paper, you can establish the light tones.

Use your preferred method to transfer the image onto your paper. My pencil lines are stronger than I would normally have them so that they show up in the photo. Try to keep them light or even use a watercolour pencil, which will blend into your work.

Select a paint with a good mass tone; I am using Phthalo Blue. Build the tones in layers, starting with the lightest on dry paper. Using a large round brush paint in the base layer, softening edges with clean water where needed in the skin areas. Leave the white of the paper where there are highlights, for example on the end of the nose; observe carefully, however, as the whites of the eyes, for example, are not truly white. While this is wet, drop in midtones to achieve soft edges. Paint hair as part of the face to avoid 'helmet hair'.

Dry and remove unwanted pencil. Check by feeling with the back of your hand; if the paper is cool then there is residual moisture and you will need to dry further.

The second layer is a slightly darker tone, but remember that because of the transparency, the layers will add to each other so do not go too dark. Work in the same way, wet on dry and softening edges. Note there are some hard edges where the shadow is. Identify areas of midtone and work these but continue into the dark tone areas. Use a thirsty brush (a clean damp brush, which will suck up the excess paint) to lift soft, lighter areas, such as the reflected light along the jaw.

Consider using a fine spray bottle in places so that you have a mix of soft and hard edges.

When you are happy you have established the midtones, let the painting dry fully. Use a gentle hairdryer if you wish, but make sure the paper returns to room temperature otherwise the next layer may dry patchy. Try to stick with the larger brush and add in darker tones in a third layer.

Now it is time for the darks. Move to a smaller brush and more concentrated paint. A lot of the darks are in the hair; aim to paint

Once dry, using a more concentrated wash, the midtones start to establish form.

Move on to the shadow areas with a further wash.

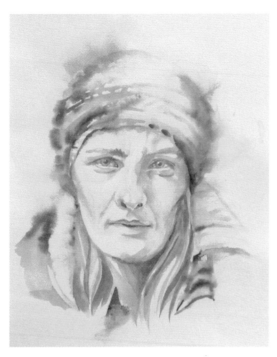

Using a smaller brush and more concentrated paint, the darkest details are added.

them as blocks of tone and not individual strands. Note that often the darkest point on the face is between the lips and not just in the nostrils and pupils. When painting a portrait with both eyes showing, try to make one a little more dominant, so that the viewer knows where to look first. If they are both equally clear, we will feel cross-eyed looking at it. Do get the pupils looking in the same direction and make sure the highlight in both eyes makes sense.

Once you are happy with the darks, let it dry. You could take a black and white shot to check you have a good range of tones or use your previous tonal swatch to check. In your portrait, your whites will have no paint on them, your lights will have one layer, your mids will have two and your darks will have three. If you have lost a highlight in the eye, now is the time to get it back. You can use a spot of white gouache, an opaque white pen or, on dry paper, use a scalpel to lift a nick of paper (*see* What to Do When Things Go Wrong).

WHAT TO DO WHEN THINGS GO WRONG

Do not panic. Though watercolour has the reputation of being hard to correct, there is usually something you can do. Often it is best to wait until the paint is dry to correct a mistake.

You may be able to lift an area with a damp brush; you can soften edges in the same way. If you have lost the white and lifting does not work, consider adding white gouache; use judiciously as it can look obvious. You might also consider (especially for the sparkle in the eye) using a very sharp blade and scratching out a tiny piece of paper. It will reveal clean white and will bring the portrait to life immediately.

Also remember about contrasts. If you cannot make an area lighter, consider making the area next to it darker so that the first appears lighter.

TAKING IT FURTHER

Why not add a background to your portrait, to help tell a story about the character of the person? It could be a regular pattern, something specific or more abstract, without detracting from the portrait. Text can also be interesting. It is good to get this in early on, so that hair can overlap it and make the background more integrated.

Think about adding spot colour to a monochrome. Perhaps a pair of scarlet lips or a colourful flower in an otherwise neutral portrait. This can really bring a piece together.

MONOCHROME ON A TONED BACKGROUND

Working on a toned background adds a new dimension to your monochrome. While toned papers such as Strathmore Mixed Media are available, you can readily tone your own with a

Tone your paper with tea or coffee, creating interesting marks by dropping in water as the wash dries.

Using a single colour paint in the midtones.

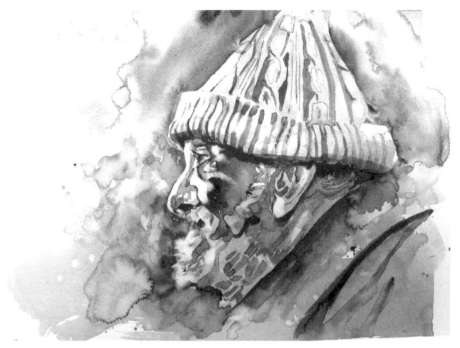

With your selected colour at full strength you can place in the deepest shadows.

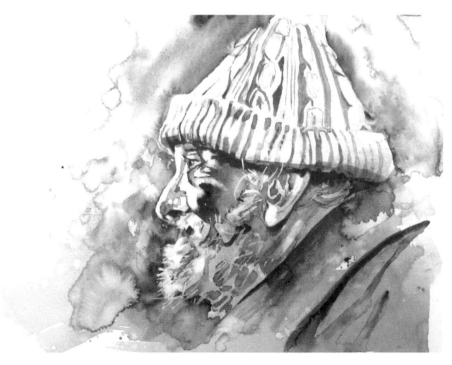

You may be able to lift the background colour to rediscover highlights or use an opaque white to regain them.

dilute wash of watercolour or ink. The toning can be uniform or variegated. As you no longer have the white of the paper, you may need to add highlights using white gouache, white watercolour (Chinese or Titanium White) or a white pen/marker (for example Posca).

To engage our sense of smell and taste, we will tone the paper with tea or coffee. Please note that both of these tend to be acidic, so may degrade your paper over time. If this worries you, use a wash of watercolour instead.

Dissolve a teaspoon of instant coffee in boiling water and cool, or make strong black tea by steeping a bag in a little boiling water. Now apply to your watercolour paper with a wide brush, or just wipe the tea bag over the surface, depending on whether you want an even or uneven coverage. Spatter clean water into the drying wash to create lighter areas.

Allow to dry and then transfer your image. Consider placement carefully. I noticed an accidental white area, which would be perfect for the nose, so placed the image appropriately.

Using Van Dyke Brown, start to paint the shadows. Sepia or Burnt Umber would also work. The toned paper is a light midtone so only paint shadows darker than this. You can darken the background to throw the profile into relief. The coffee moves easily and forms interesting marks and blooms.

Once this first layer is dry, deepen the shadows using a strong mix of watercolour. I also indicated the pattern on the hat. Paint dark areas to indicate the shadow in the beard, leaving strands of light showing.

With regards to the light areas, you have a couple of options depending on what you have toned the background with. If the colour lifts easily, you can use a damp brush and blot away to reveal lights (coffee is good in this respect).

If you have used a staining colour or tea, you will not be able to lift, so you will need to use opaque white to create highlights. Do not be tempted to paint every strand of the beard – simply indicate that it is present.

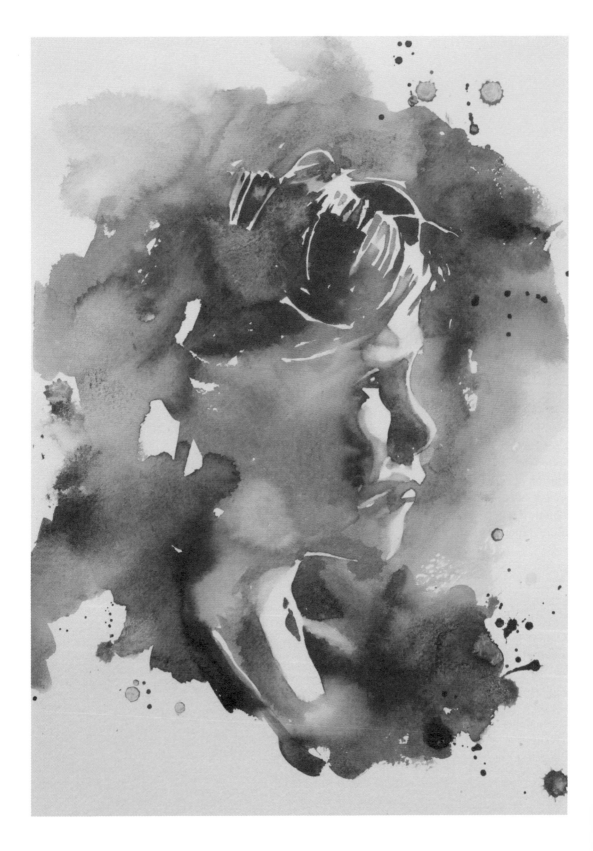

PLAYING AROUND WITH COLOUR

Having put tone to the test, we will stretch the idea further to substitute colours of the same tone to add emotion and personality to our portraits. Capturing the character of the subject is as important as capturing a physical likeness. By getting rid of the need for matching colours to reality, we may get closer to the truth of the person we are painting.

Colour value switching is the process of swapping colours of the same tone but different hue. The face is still recognizable but with added drama and personality. If tone gives the illusion of volume to your painting, what is the role of colour? It is to give emotion to a piece. Colour is not irrelevant, it is just that tone is more important.

WARM-UP EXERCISE

If you have the swatch strips from Chapter 2 you can use them here. If not, choose five different colours. Complete tonal swatches for each, aiming to obtain seven to nine even steps from full strength to the palest tint. Once dry, cut them into squares and mix them up. Now arrange them with the darkest tones together, irrespective of hue. Carry on until you put all the palest tints together.

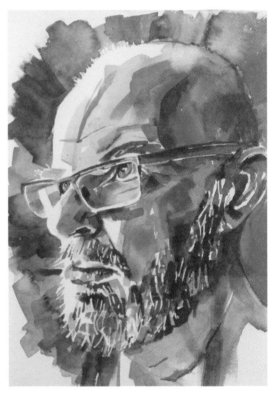

A strongly lit subject gives areas of sparkling white to play against the riot of colour elsewhere.

To test your tonal perception, take a black and white photo. You should have equal shades of grey. Note how some colours are incapable of achieving the darkest tones. In a painting you could substitute purple for a dark brown,

A portrait doesn't have to be complicated. By substituting colours but being true to the tonal map you can harness the emotional language of colour.

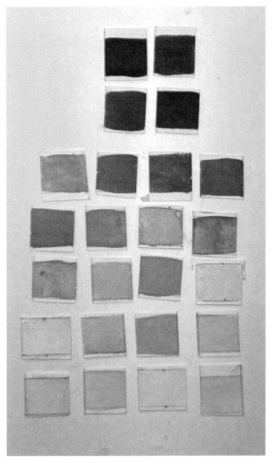

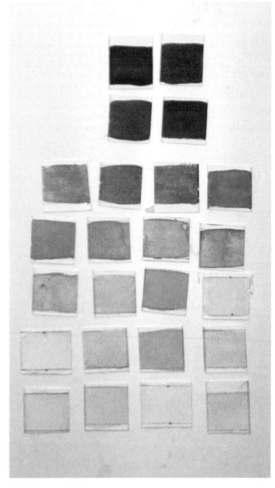

Arrange swatches of different colours into groups of the same tone to start training your eye to separate these two qualities of each colour.

Check your work by taking a quick black and white photo.

but never a yellow for the same dark brown. Sure, you need to take into account whether colours 'go' with each other, but substituting hue is how a rainbow zebra still looks like a zebra.

A LITTLE COLOUR THEORY

Colours trigger emotion, though which emotion varies by person and culture. Is red the colour of danger or passion? Is blue serene and calm or cold and frigid? Do consider what emotions colours trigger for you and try to use them in your paintings.

Colour has three significant properties – value, saturation and hue.

- Value – how light or dark something is – the same as tone
- Saturation – how intense a colour is. This is sometimes call chroma. Colours often start to lose saturation (become muted) as you mix them
- Hue – the actual name of the colour, such as blue or green

We are taught that there are three primary colours – red, yellow and blue – from which we can mix secondary colours – orange, green and purple. When you mix these secondary colours, you get tertiary colours, and our expressive language starts to run out of steam. Lime green is a tertiary yellow-green, but we have no language for orangey-red.

THE COLOUR WHEEL

Laying colours out on a wheel helps us understand them. Colours opposite each other on the colour wheel are called complementary colours. These pairings have important properties. Next to each other, they vibrate with energy and set each other off,

but when mixed they neutralize and subdue each other.

When people refer to the temperature of a colour it can be confusing. Colours on the red side of the colour wheel tend to be referred to as warm and those on the blue side as cold. Just to mix things up, however, you can get a cool red and a warm blue. This refers to the underlying bias. If it is a purple-red (that is, there is some blue in it such as in Alizarin), it is called cool. If it is a purple-blue (there is a touch of red in the blue such as in French Ultramarine), it is called a warm blue.

In the colour wheel shown later on page 45, a warm and cool version of each primary is shown, along with vibrant and muted secondaries. We will find out more about colour mixing in the next chapter.

The colour wheel helps us order colours to understand primary, secondary and complementary colours.

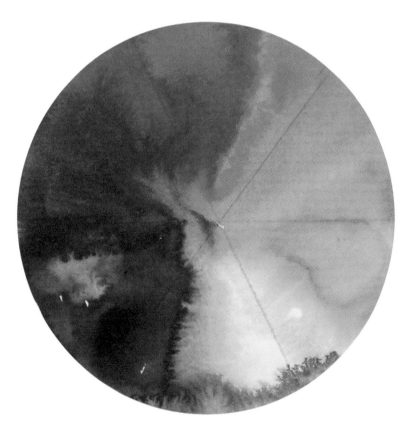

WHERE DOES YOUR PALETTE LIE ON THE COLOUR WHEEL?

Analysing your favourite colours will really help with colour mixing or matching. Go through your palette and place them on the colour wheel. Ask if something is a bluey-green or yellowy-green, for example, and that will identify the area to place it. But also consider saturation/chroma. Ask yourself if the colour is high or low chroma. If it is subdued, place it closer to the centre. Neutral black will be at the very centre, but a blue-grey (for example Payne's Grey) would be placed towards the centre in the blue segment. A warm brown might be near the centre but in the red segment.

BRUSHES

There is no such thing as a magic watercolour brush that will transform your painting skills. It is the miles you put on the brush that make all the difference.

Brushes can be made from either natural hair or synthetic fibres, each with different characteristics and price points. The final choice is yours, but if you buy a good-quality brush and look after it, it should last a long time.

It is worth knowing what to look for in a brush:

- How much fluid can it hold?
- Does it have good flow control? Is the colour released gradually from the brush?
- What is the level of 'snap' – will it spring back into shape during use?
- Does it come to a good point while wet (only relevant for round brushes)?

Watercolour brushes come in all shapes and sizes: rounds, flats, hakes, fans, riggers, swords, and so on. Each offers different mark-making possibilities, and while you will no doubt accumulate a wide range of brushes, a few will see you through most projects.

In general, the larger the area you are painting, the larger the brush should be. If you aspire to paint in a loose style, always choose a brush that feels slightly too large for the area you are painting. This will keep your brush strokes to a minimum and help you avoid the temptation to fiddle.

Most of the painting in this book uses a round size 12–14, a medium-round size 7–8 and a rigger size 2.

BRUSH CARE

- Throw away the protective sleeve of a new brush and do not try to replace it, as you will damage the outside hairs.
- Do not leave a brush standing in your water pot. This can ruin the point and loosen the glue under the ferrule.
- Clean thoroughly after use, especially at the heel. If pigment remains it can cause the hairs to splay out, which is especially important if you use your brushes with waterproof ink.
- Reshape while wet.

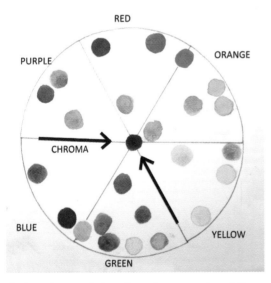

Go through your palette and see where your colours fall on the colour wheel.

- If possible, hang brushes hair-side down or dry flat before storage.
- Do not store standing on the point.
- Never use a good brush with masking fluid.
- Never be tempted to lick your brush to get a good point.

PUTTING IT INTO PRACTICE

By using a reference with few, if any, midtones, you can create a strikingly simple portrait. In a monochrome portrait we stripped out the colour choice and here we are keeping the tonal

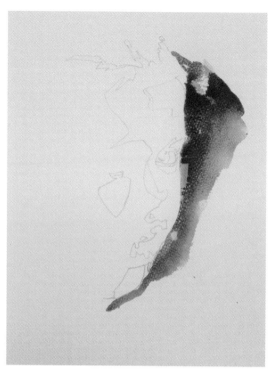

Using plenty of water is key to allowing colours to mix and flow on the surface.

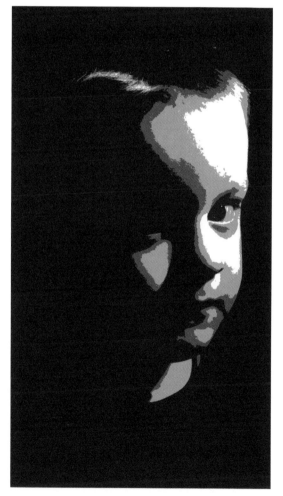

An image with primarily light and dark tones makes the perfect reference for this exercise.

Each brush stroke is of a different colour as the wash grows.

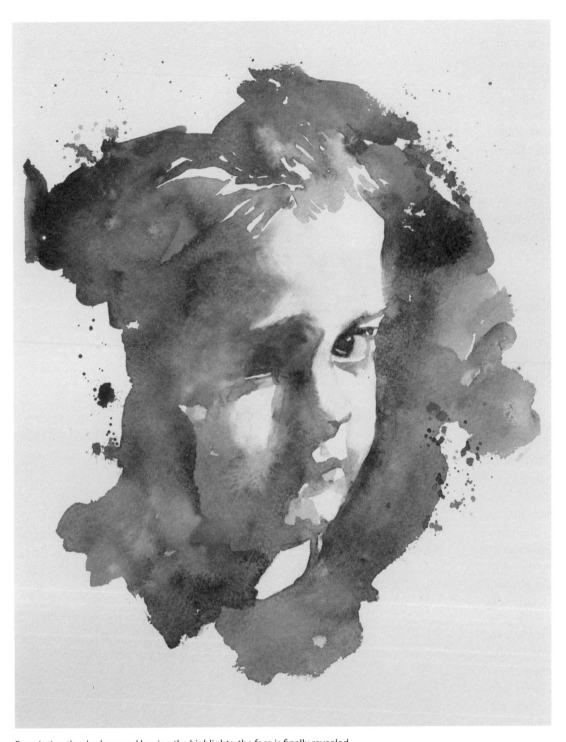

By painting the shadows and leaving the highlights, the face is finally revealed.

choice very simple. This should prove to you that in watercolour we are painting the shadows not the objects, and that shapes and tone are interpreted by our brains as faces.

Choose a strongly lit reference photo in black and white, with large areas of shadow and only a few areas of white. Photographers call this Rembrandt lighting. You will find it helpful to posterize your image to clump the areas of tone together.

Transfer the image to the paper, outlining the brightly lit shapes. If you cannot see an edge, do not draw it.

You can safely use any combination of colours with a good tone mass and it is a great way of using up leftover paint – here, I used Dioxazine Purple, Van Dyke Brown, Sap Green and Phthalo Blue. Work on dry paper; paint the entire shadow area as one wash, working wet up to wet and dropping extra colour into the wet wash if required. You will need to work quickly to avoid edges drying. If it is very warm, you might wish to wet the entire shadow area before you start, to give you more working time. This is sometimes called growing a wash.

There are very few midtones or soft edges, but look to find any and use a clean damp brush to soften them or to pull some of the wet colour into that area to create a midtone.

Consider where you want the shadow area to stop and what shape it makes. You could take it to the edge of your paper or finish it in a random yet pleasing shape. If you want to, you can spatter in either clean water to create blooms or paint to create spatters and movement.

Allow to dry, erase pencil lines and adjust any edges with a damp flat brush to lift or soften them. Avoid fiddling. This portrait succeeds on the freshness and simplicity of the approach.

Now look at your portrait. The random white shapes coalesce to form a face. We need very little actual information to recognize human features. The colour plays a huge role in the emotion of the piece. Note how working the large shadow areas and connecting them

creates an interesting and dynamic portrait. Use this knowledge in your future portraits – paint shadows and look for opportunities to join areas of similar tone.

SWITCHING COLOURS – RAINBOW PORTRAIT

Once you are confident of the process we can develop more detail in the midtone range and introduce a more ambitious palette to paint a fully value-colour-switched portrait.

Choosing a reference with a good range of midtones will set you on the right track for a full value-colour-switched portrait.

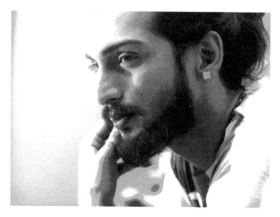

Identify areas of similar tone that can be painted as a large continuous shape.

Choose a reference with strong lighting, but with a full range of midtones visible. The clean highlights will play well against the riot of colour. This time we will be painting the shadows and half-shadows, using the light of the paper as the very lightest tones. With time, you will train your eye to distinguish the lights and darks in any reference, but you should make life a little easier for yourself at the beginning by selecting something with obvious light.

You may be tempted to follow the colours in your photo, so turn it black and white. This will help you concentrate on tone above all. If you find posterizing the photo helpful, do so and select five or six tonal steps.

Choose five or so colours that appeal to you. You will need one or two with a good mass tone. If you only select pinks and yellows, with the best will in the world, even at full strength, they will only ever achieve a midtone. Swatch them out on paper and see how they behave next to each other and painted wet up to wet. Identify if any need to be kept apart as they make a muddy hue when mixed. I used Phthalo Blue, Green Gold, Burnt Umber, Dioxazine Purple and Transparent Grey – not colours you would find on any face. This was quite an extreme colour choice for the sake of demonstrating the process.

Transfer the main features to the paper in your preferred method. I decided to leave out the hand for simplicity and the earring as I did not like it. You may find it helpful to outline the areas of distinct tone, especially in this photo where they are crucial to the composition. Keep the pencil lines light if you do not wish them to show in the final piece.

The area on the right-hand side formed by the hair and beard make a good place to start. Using plenty of water (you can clearly see the shine in the photo) and a size 10 brush, start growing the wash as you work down the shape, making sure to leave the beautiful highlights. Growing the wash means that though the paper is dry, you can change the colour on your brush every time it touches the paper as you extend the shape.

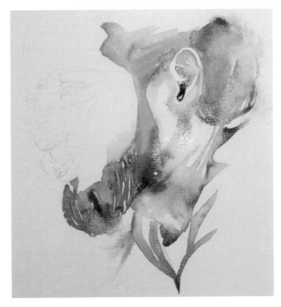

It is possible to paint most of the facial features as a series of interconnected shapes.

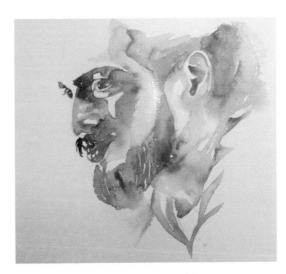

The background helps find the edges of the nose and forehead.

Extend the midtones down into the ear, neck and clothing area, again connecting areas as much as possible. You can also soften edges using a small spray bottle around the beard and back of the head.

While this area is drying, move on to the facial features, which can be painted as one

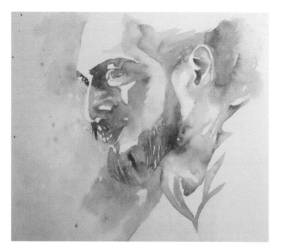

A second layer helps add richness and depth to the mark making.

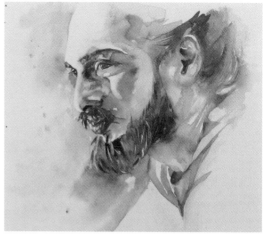

The shapes do not have to be flowing washes, of course; here a flat brush with squares of colour build up the image.

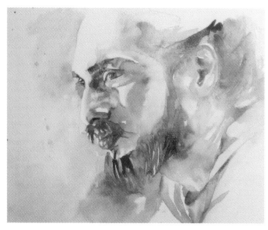

Final details and deepening the punchiest darks help add impact to the portrait.

shape (apart from the far eye). Again, each brush stroke is a new colour and grows the shape. It is important to keep the leading edge wet. I softened the edge of the beard where it meets the face.

Let this dry and erase any lines you don't want. The background is a similar tone to the highlights on the face, but by putting a large darker wash into the background, you can define the forehead and capture the light on the subject's nose. Altering the tone to help you better tell the story of the painting is certainly justified. This is 'negative painting' or a 'found edge'. By painting around the subject you discover the edges of the subject itself. Spattering in colour while this wash is damp gives soft variation. We do not want the background to compete with the face.

With layer one firmly in place, it is time to develop more depth and movement. The eyes are defined and the beard has a second wash completed in the same way. The hair and features are also layered.

Now allow things to fully dry and take stock. What is working, what isn't? Do any areas need to be adjusted in tone? Do any edges need to be sharpened or softened? Have any highlights been lost?

This final stage is well worth taking your time over. Really contemplate what will add and what will hinder. If you are not sure, put your painting aside for a few days and then look with fresh eyes, remembering it is better to undercook it than overcook it. At this point, I define and darken the hair and beard and sharpen up the eyebrow and eye area, before calling it done.

You can use colours with high or low chroma to achieve a different effect. Once you are happy with the process, you can add in patterns and stencils to abstract the image slightly.

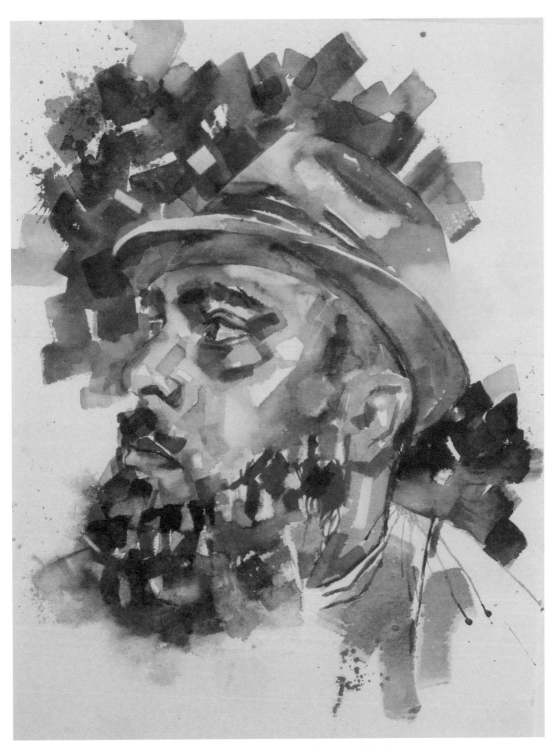

Using different brush strokes changes the energy of the portrait. Here flat marks add excitement.

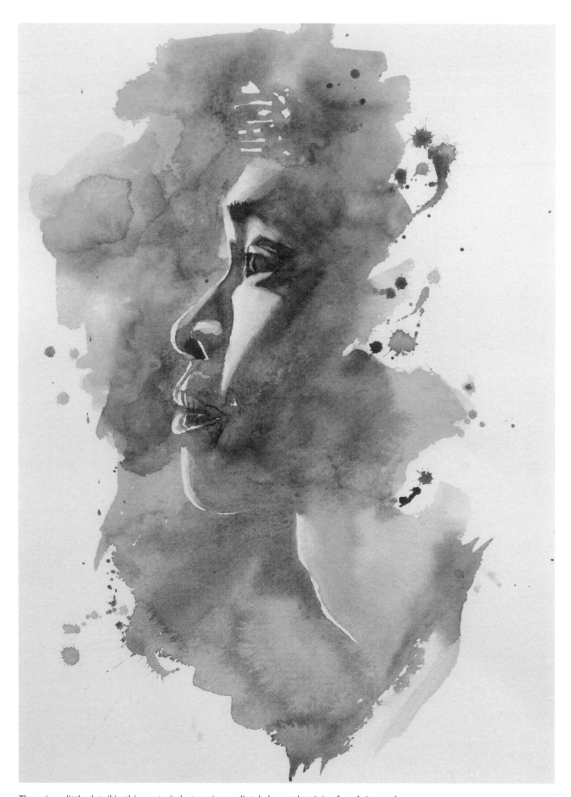

There is so little detail in this portrait, but we immediately know that it is of an Asian male.

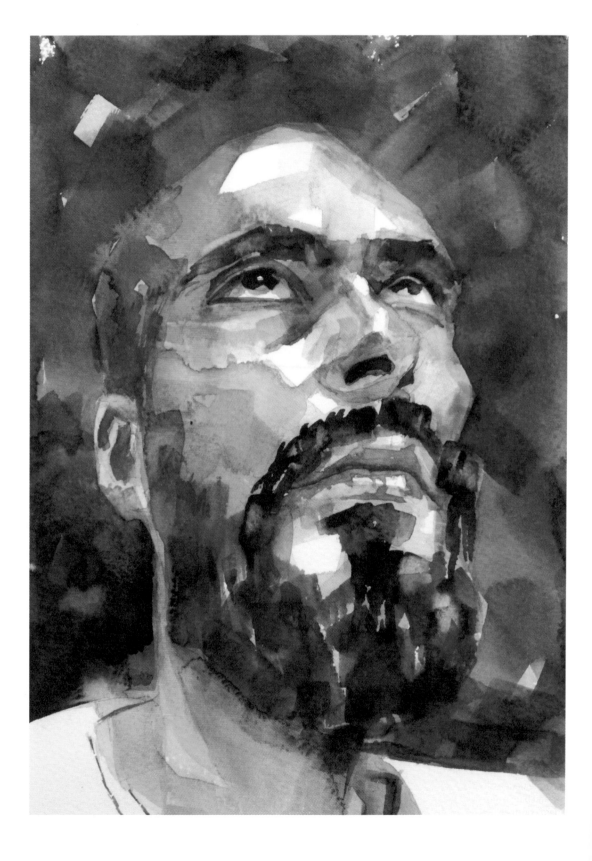

LAYERING COLOUR

The transparency of watercolour is part of its beauty. Colour depth and richness can be built up in multiple layers. The first layer, or underpainting, sets the foundations for the whole piece. If you are aspiring to paint in a loose and lively manner, it makes sense to try to achieve this in as few layers as possible to retain the transparency and freshness of your work.

In the monochrome portrait, we worked in layers of the same colour to build up the tonal map, which in turn created our image. In the colour-value-switching exercise, we were more direct, aiming to get tones correct at the first pass, but fine-tuning them in the subsequent couple of layers.

In this chapter we will explore building up layers of different colours to create the hues and tones we want.

MORE ABOUT WATERCOLOUR PAINT

It is worth understanding some of the technicalities of your materials so that you can get the most out of them.

Quality
Watercolour is generally available in two qualities – student and artist. Student colours are not necessarily poor quality; indeed, the student range from the large manufacturers are uniformly good (such as Cotman from Winsor & Newton). It is simply that student quality does not use the most expensive pigment. Instead, they use ones that approximate the colour, and you will see 'hue' after the name. They may not use as much pigment and may use fillers and extenders. In general, they are not as lively on the surface as artist-quality pigments. They may not be as light resistant.

Format
Watercolour is available as pans or tubes. This is not an indication of the quality, it is simply a change of the formulation, with tubes having more gum arabic. Pans are convenient to transport, so if you paint outside or go to classes, these may be better. Tubes are more economical in the long run and it is easy to mix up large creamy washes, so if you paint larger pieces in a studio setting, these may be best.

Properties
If you are using tube colours, you should be able to find a lot of useful information printed on the packaging. With pan colours, you may have to consult the manufacturer's colour chart. As well as showing which pigment/s are contained, it

A purple underpainting, with subsequent layers of yellow, red and blue painted with a flat brush, makes for a high-energy portrait.

will show if the colour is opaque, semi-opaque or transparent. It should say whether it is a granulating pigment and whether it is staining. There will also be an indication of its light fastness. This information helps you predict how the colour will behave and you can choose the right one for the effect you desire.

More about Properties

A colour is said to be staining if it sinks into the paper and cannot be removed with a damp brush. The opposite is lifting. A colour is said to granulate if it 'curdles' on the paper – the pigment particles clump together to give a mottled look. This can add interest to the

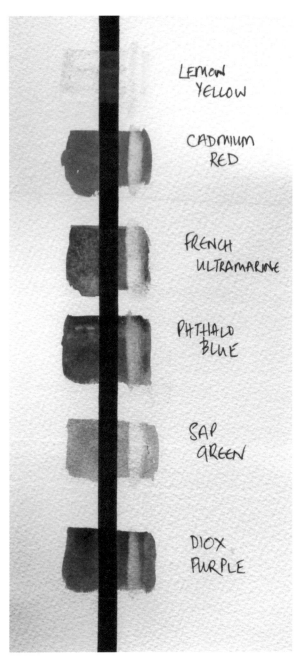

Being able to identify whether a colour is opaque or transparent, staining or lifting, will help you choose the right paint for each occasion.

LEMON YELLOW

CADMIUM RED

FRENCH ULTRAMARINE

PHTHALO BLUE

SAP GREEN

DIOX PURPLE

appropriate subject – you may not want a blotchy skin but would be perfectly happy with a blotchy landscape.

All watercolours are transparent; some are more transparent than others. You can readily test this by swatching your colour over a broad black line. If you can see the pigment sitting on top of the line, it is opaque; if you cannot, it is transparent. Test for staining by running a damp brush backwards and forwards through a dry swatch. Now use kitchen towel to remove loosened colour. If the paper is practically white, it is a lifting colour; otherwise it is staining.

COLOUR MIXING

Building on what we learnt about the colour wheel in the last chapter, you may be wondering why we do not have just three colours in our paint boxes. We all learnt at school that there are three primary colours from which all other colours can be mixed.

It is important to understand that in our paint boxes, the colours are not pure primaries. We might have Cadmium Red, which is not a primary red; it has a bias towards yellow. We might have Alizarin, which is a crimson red that has a bias towards blue. Understanding the bias is important to let you mix the colours you want. If you mix all three primaries you get a neutral black or brown. Therefore, if you mix a green from blue and yellow, but your blue has a bias towards red, you are really mixing all three primaries and you will get a subdued green. Should you mix a blue with a yellow bias and a blue-biased yellow, you are only mixing two primaries and will get a more vivid result.

Understanding the bias of colours will help you mix vibrant or subdued colours.

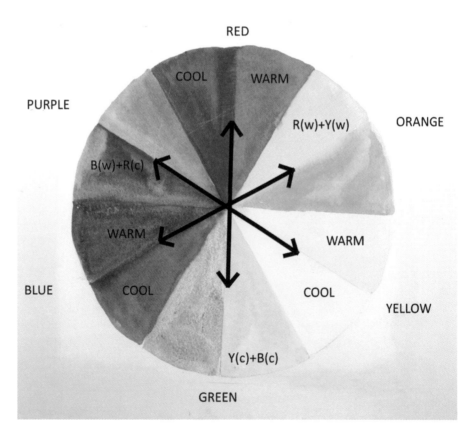

TIPS FOR COLOUR MIXING

- To reduce the saturation of (mute/subdue) a colour, mix it with its complementary colour. For example, mute a bright green by adding a little red.
- To darken the tone, add further pigment; to lighten, add water.
- To mix a natural black, combine two complementary colours, for example Burnt Sienna and French Ultramarine.
- To mix a bright secondary, identify the bias of your paints and choose primaries that are biased towards each other, for example a warm yellow with a warm red make a bright orange. A cool blue and a cool yellow make a vibrant green.

Tan

One of the most common questions is how do I mix skin tone? The immediate answer is there is no such thing as flesh colour. Even taking out the differences between black, white, Asian, Hispanic and Middle Eastern skin tones, if you look at a face there are areas that may appear bluish, or reddish, or green or purple or pink. And of course in the last chapter we saw tone was more important than hue.

However, as the overall colour might be a brownish tan, for example, it is worth thinking of some good combinations to act as starting points. We have seen that complementary colours neutralize each other, so red-green, yellow-purple and blue-orange

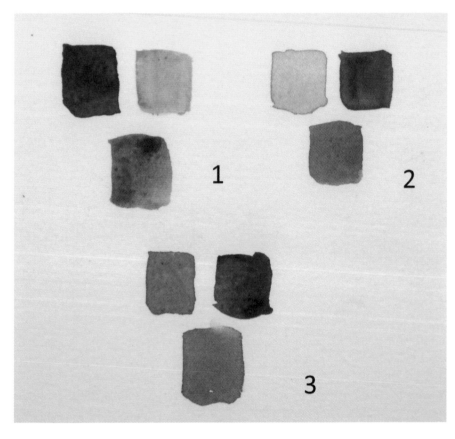

Using complementary colours gives exciting tans and browns to use in skin.

combinations are great for lovely brown and tan colours:

- Dioxazine Purple and Quinacridone Gold (1)
- Perylene Maroon and Sap Green (2)
- French Ultramarine or Indanthrone Blue and Burnt Sienna or Burnt Umber (note that Ultramarine granulates) (3)

How to Mix Colours

In watercolour there are three ways of mixing colours.

In the Palette

If you want a uniform colour then you can mix it in your palette. It is wise to mix more than you anticipate needing, as matching an exact colour can be a challenge and your wash may dry while you are doing so. Also, mix your colour to a creamier consistency than you anticipate needing. Adding water is quick, but taking water

out is not! The downside is that consistent colour might be somewhat boring. A good rule of thumb is to not have more than a square inch of the same colour before tone or hue is varied.

Wet in Wet

If you wet your paper and drop in the colours required to make the desired hue, they will mix in pleasing and unexpected ways. This can add lots of visual excitement but is potentially hard to control.

In Layers

Because of watercolour's transparent properties, thin layers (called washes) allow the previous colour to shine through and the colours mix a little like stained glass. This allows very fine adjustments to colour but also gives exciting glints of the constituent hues. The order in which you glaze will impact the final result and each should be dry.

Lemon Yellow and Prussian Blue can be mixed to green in three different methods.

Working in Layers

Watercolour dries about 15 per cent lighter than when wet, so it is often difficult to obtain the correct tone first time. It is therefore normal to build paintings in layers with the added advantage that the transparency of the paint allows previous layers to shine through the top one, creating rich and glowing colours.

- Work light to dark.
- Ensure each layer is dry.
- Use staining colours in the first layers.
- Be aware of the opacity of colours used in the final layer.
- Avoid overworking and muddying the base layers.
- Use a good-quality paper to allow multiple layers.

LOOKING TO THE STARS WITH EXPECTANT EYES

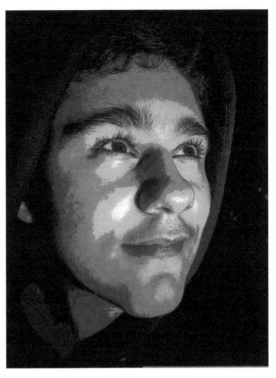

Manipulating your reference can help train your eye and spark creative thoughts.

I rather fell in love with this reference photo when I saw it and wanted to capture the hope and freshness of this youth.

Posterizing the photo helps reveal interesting colours and shapes. With time you will not need to do this, but it is a great way of training your eye and brain. Transfer the image to your paper and consider outlining the tonal shifts to guide you in your painting.

Prepare your colours. As we are doing large washes, prepare them in advance and mix more than you anticipate needing, so you do not have to stop in the middle of a wash. In this portrait, I used Sap Green, Perylene Maroon (mixed to produce a beautiful tan), Quinacridone Gold, Burnt Umber, Quinacridone Sienna and Transparent Grey.

Starting with the largest wash possible, paint the entire face and continue over the hood wet on dry, with a weak mix of Sap Green and Perylene Maroon, leaving highlights untouched.

Note that there is a lot of yellow around the temples and the jaw, so you can drop in Quinacridone Gold while the wash is wet. Also start to darken down the neck with a stronger mix of the same colours.

Having allowed the first layer to dry, apply a second wash of a similar colour, leaving the lighter tones untouched and again dropping in deeper tones of Burnt Umber into the wet wash around the nose and eyes.

The next layer can be a little darker and you can also touch in Perylene Maroon in areas of warmth, such as the lips, cheeks and nose. Darken the hair, not getting caught up in every strand but suggesting the curls framing the face.

Brush in the hood using a flat brush and Transparent Grey plus Burnt Umber dropped into the wet wash. Make sure the edges form an interesting shape and allow dry brush marks to

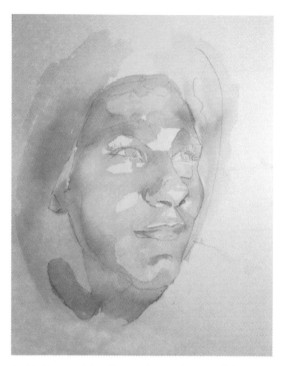

Highlights are retained but the first wash aims to link areas and features.

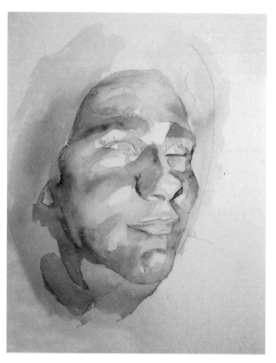

The second wash places midtones but still links areas into larger shapes.

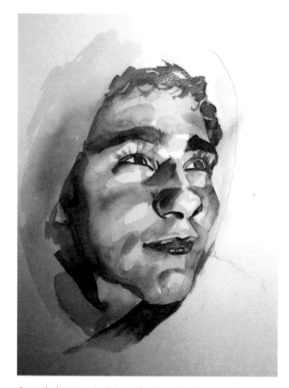

Once darks go in, individual features start to emerge.

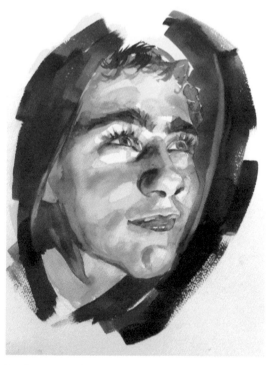

Leaving some ambiguity in a painting engages the viewer.

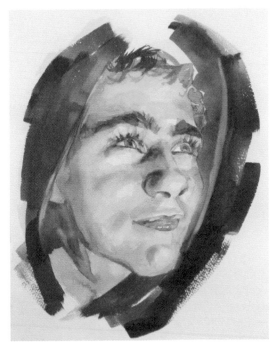

A warm overall wash softened and enhanced the portrait.

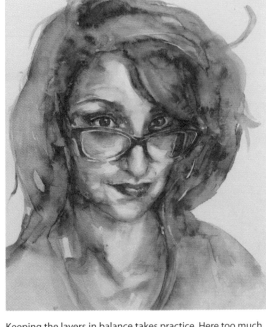

Keeping the layers in balance takes practice. Here too much pigment was used and the blue dominates.

form. Run a damp brush along the edge of the hood to lift a soft highlight while the paint is still damp.

With it all dry and any pencil lines removed, assess the painting. I had painted under artificial light and in the natural light of the next morning, the portrait looked far too cool and harsh for the youthful face. I decided to gently warm things up by using a dilute wash of Quinacridone Sienna with a tiny touch of Perylene Maroon. I made sure no hard edges formed and used a short flat brush to 'tickle' and soften some of the edges from the initial layers. I was far happier with the outcome.

UNDERPAINTING

Have you heard of the *grisaille* technique (pronounced like the Palace of Versailles)? It's a term used in oil painting where translucent colours are laid over a grey underpainting. In watercolour, working over a cool

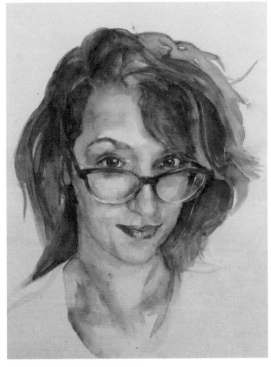

The same portrait in the same colours but with more balanced layers gives a more natural effect.

underpainting can help build clear and glowing skin tones.

The underpainting sets the overall mood for the painting. It starts to build shadow areas and it gives a cohesive look to the piece, as it may glint through in many areas. The concept is to paint a tonal portrait and then to build realistic tones on top using multiple layers. To demonstrate the process we will keep each layer to one colour, but as you gain in confidence you can build wet-up-to-wet layers.

You can select any staining, transparent colour with a good tonal range to start off with. Dioxazine Purple is dramatic; Phthalo Blue is ethereal. A cool colour works well as it seems easy to warm a cool, rather than cool a warm colour.

Perfect Pigments

Because we are going to layer our colours, it is important to select those that are staining and transparent, especially for the base layers. You could use more opaque lifting pigments in the final layer if required.

The staining property is required so that the paint will not lift and mix with the layers placed on top. The transparency allows the base layers to shine through.

Portrait with a Purple Underpainting

Colours used are Dioxazine Purple, Quinacridone Gold, Quinacridone Sienna, Perylene Maroon, Prussian Blue and Burnt Umber.

First transfer the drawing using your favourite method. Crop if you wish and leave out any elements that do not appeal. You might find it easiest to outline areas of tone, if you want to ensure you capture them. My lines would usually not be this detailed or strong, but they are necessary to show up in the photo.

Using Dioxazine Purple, paint a monochrome portrait, very much in the

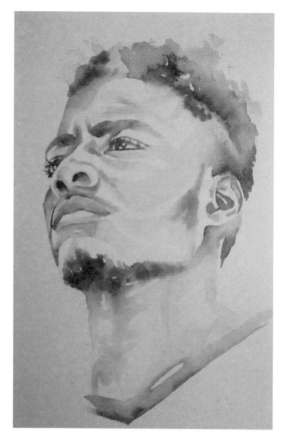

A purple underpainting gives structure to the entire portrait.

manner of the portrait in Chapter 2. Avoid going too dark, even though this is a dark-skinned subject – certainly not as dark as if this were to be purely one colour. This ensures the first layer blends successfully and does not dominate. Do not forget to leave whites.

This first purple layer takes the longest as you are building the structure of the entire portrait. Allow to dry fully and erase any lines you do not wish to show in the final piece. Think about hard and soft edges and taking some of the colour into the background.

A purple underpainting works for paler skins too, though you need to be even lighter on the initial wash.

As yellow and purple appear opposite each other on the colour wheel, they neutralize each

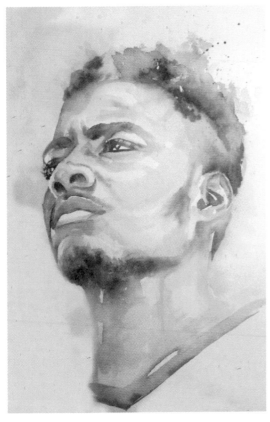

By glazing with yellow, the purple is neutralized.

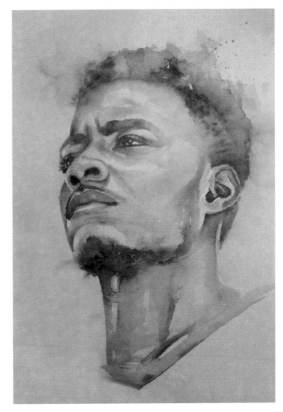

A warm layer usually follows, perhaps reds, oranges or Burnt Sienna.

other when mixed. If you put yellow over purple it will make a brown.

Select a transparent staining yellow, so the purple can mix with it like stained glass. I used Quinacridone Gold, but Azo Yellow might be good. Now paint where you can see yellow in your reference photo. If you think this is mad, think of the brown being the melanin in your skin and the yellow being the fatty layer we all have.

As you become more confident with the process, you might mix a cool and warm version of the colour in a single layer, depending on what you need for your particular portrait. To start with, however, it is easier to stick with one colour per layer.

The next layer would normally be a red layer (think of the red as representing the blood in our skins). However, in this particular portrait I could see little red and opted for a warm Quinacridone Sienna, Burnt Umber and Perylene Maroon.

Gently layer in areas where you can see warmth, such as the lips, ear and above and neck. Soften edges as desired.

Other transparent reds might include Alizarin Crimson, Pyrrole Orange, Perylene Red or Quinacridone Rose, Brown Madder or Permanent Rose. Ears, nose and lips tend to have a plentiful supply of blood. Often a touch of red around the eyes brings them to life so look carefully in this central zone.

The final layer is blue. Once more, wait for your painting to dry. Most blues are dominant, so a light touch is called for. You are looking for transparent, staining colours again. Prussian Blue

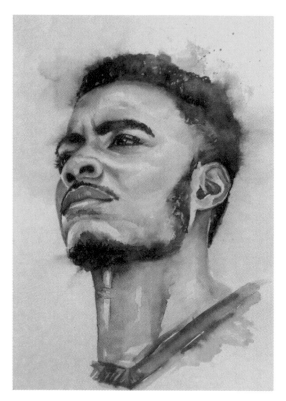
Blues and darks add final punch to the piece.

or Phthalo Blue would work – beware as both are very fierce. Payne's Grey might be tempting with its blue undertones, but some are quite opaque. Transparent Grey with a touch of Phthalo Blue makes a good option. Sepia, Burnt or Raw Umber mixed with the blue is another option.

Here I used Transparent Grey and Prussian Blue, concentrating on the darkest areas of hair, beard and eyebrows and softening edges to allow the blue to shine through more.

Assess and Reflect
It is worth drying your portrait and giving your eyes a rest. Now carefully consider which areas work and which don't. Are there edges to be softened? Does anything need to be darker, lighter, warmer or cooler? Right at the end you

might use something a bit more opaque to calm a colour down. However, the fewer layers you use, the more you will retain the freshness of your painting.

Portrait with a Blue Underpainting
Although a fair skin can be rendered with a purple underpainting, a blue one gives a more ethereal look and can be a beautiful way of painting translucent skin.

Swatch your colour palette and ensure the colours behave in the way you expect. I used Phthalo Blue with a touch of Phthalo Green to make a turquoise underpainting. If you refer to the colour wheel you will see that orange is the complement of blue and red is the complement of green, so a pinky orange is the way to go. One might mix this from Indian Yellow and Quinacridone Rose or go for a Pyrrole Orange. Quinacridone Gold, Perylene Maroon, Sap Green and Burnt Umber complete the palette.

Having transferred the image to the painting paper, create an underpainting in a mix of Phthalo Blue and Phthalo Green. Both of these are fierce, staining colours so it is important to keep the initial layer light, avoiding highlighted areas. Add in shadows across the whites of the eyes and teeth, and treat the hair as a shape, not a collection of hairs. Drop a few sploshes of colour into the background to create a little movement as the girl turns to look at us.

Once the initial layer is dry, remove any excess pencil before going on to a warm orange and tan layer, which neutralizes the turquoise. Rather than doing a separate complete layer for each colour, you can use washes of Pyrrole Orange, a tan mix of Sap Green and Perylene Maroon and Burnt Umber to make a single unified wash.

I also added areas of Quinacridone Gold to the wet wash, as it did not seem necessary to have

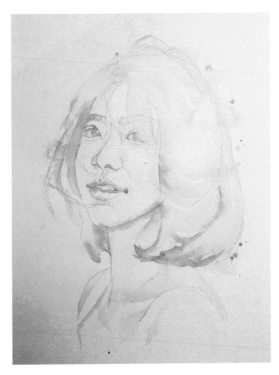

A blue or blue green underpainting brings a translucent quality to the skin.

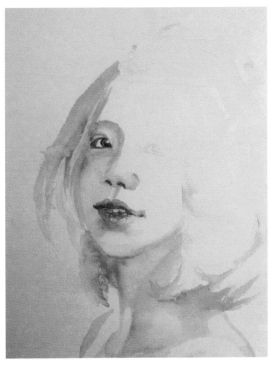

A warm layer of orange and tan neutralizes the blue-green to great effect.

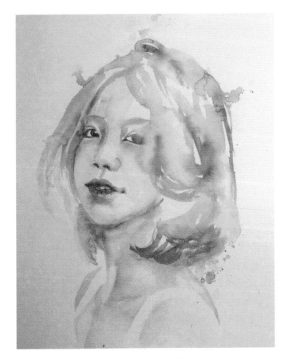

You can mix colours wet in wet in one layer as you become more confident.

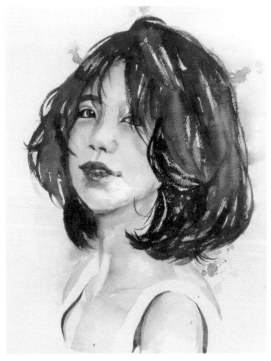

Blues and darks bring the whole piece together.

a completely separate wash for yellow. You can soften the hair with a fine spray bottle in places and drop a few spatters into the background.

Using a layer of blue and Burnt Umber, both as a dark mix and individually, adds details to the brows and eyes. Also add lively brush strokes on the hair, allowing different colours to shine though. Using the dry brush technique will add some texture.Shadows around the straps complete the painting.

FURTHER EXPERIMENTS

If you have enjoyed this counterintuitive way of painting portraits, try using different colour combinations and perhaps vary the looseness of the layers. If you have a relatively tight first layer, you can afford to be looser with the subsequent ones.

While we have kept the layers discrete colours, there is no reason why you cannot work in wet-in-wet layers using multiple colours in each.

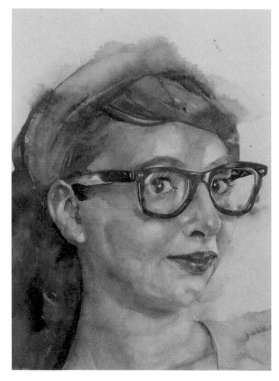

Underpainting works no matter how tight or loose your layers are, and you can experiment to get the level of looseness that suits you.

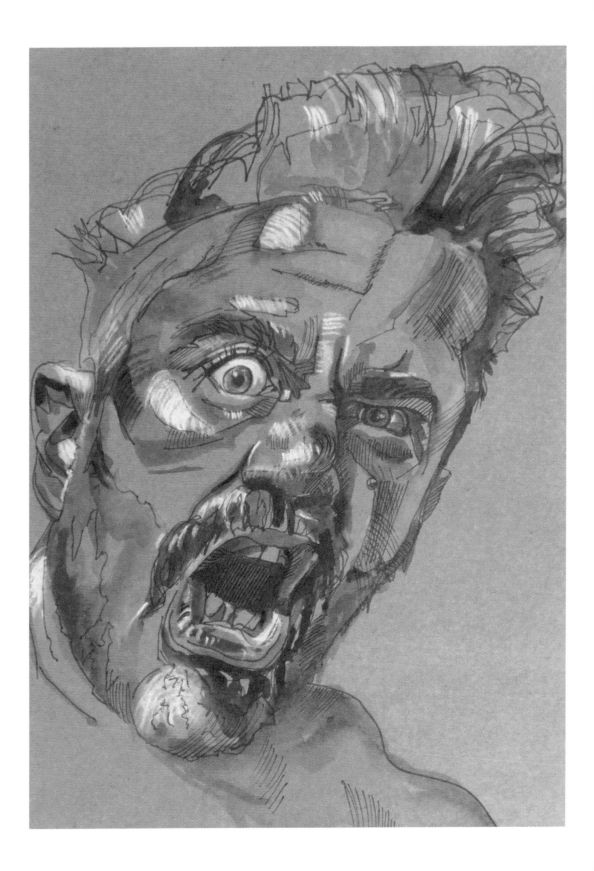

LINE AND WASH PORTRAITS

Venturing into mixed-media territory, line and wash is a wonderful way of working. It is such an accepted combination that few people think of it as mixed media. Line and wash is where painting and drawing meet, combining the strengths of each in one piece of art. The defined lines, usually developed with pen

You are always looking for the line and the colour elements to complement and enhance each other.

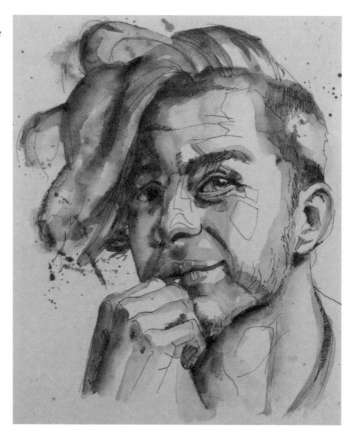

You can have such fun with line and wash portraits. Working on a toned surface brings another dimension to your piece.

and ink, combine with washes of ink or watercolour. I believe it is at its best when the sum of the ink and washes add up to more than the constituent parts by exploiting the strengths of each.

For portraits, line and wash is an excellent process. It is often fast to execute and, due to the reassurance of the line, it may be easier to be free with the washes. This adds great energy and expression to a portrait compared to line alone.

Because of the strength of the line, it is possibly less suitable for portraits of young children – it may age them. You should also consider carefully which pens and ink to use, to ensure that lines do not become too dominant or obscure the character of your subject.

If you aspire to paint more loosely in watercolour then line and wash is a great stepping stone.

RULES OF PEN AND WASH

Calling these rules is going too far; however, these thoughts may point you in the right direction.

- Aim for a balance between line and colour, but not necessarily equality.
- Avoid colouring in your drawing or outlining your painting.
- The wash does not need to relate to the line work at all – indeed, it might make for a more energetic and exciting piece if it doesn't.
- Line and wash is suited to smaller works, especially when using a dip pen.
- Consider the weight of your line in relation to the size of your work.
- Either line or wash can start the process. If line goes first, it defines edge and detail, followed by wash to add colour and value. The use of wash first will establish volume and value, with

line adding definition. Conversely, the artist can alternate to build the image.

- Each layer needs to be dry before proceeding.
- Consider the opacity of your paints if washing over ink, so as not to obscure the line.
- Tone can be developed with the line (for example hatching) with the washes, or with both.
- Broken lines are often more expressive.
- Ink cannot be erased, but don't panic if you put in the wrong line – just put in the right one too. Our eyes prioritize the correct line and it is surprising how mistakes can be camouflaged.
- Use wet in wet and wet up to wet for the wash and create a movement through your work.
- Stop too soon rather than too late; you can always add more line or colour later, but taking away is hard. Aim to stop at 90 per cent of what you think you need to do.

MATERIALS

To avoid nasty surprises, it is vital that you understand your materials.

Ink

Ink differs from watercolour. Ink is a liquid with a pigment or dye-based colouring used for painting, drawing and printmaking purposes. It may be waterproof, water-resistant or water-soluble. Watercolours are pigments held together with binders that are diluted with water to use. They are always water-soluble.

Many drawing inks will fade once exposed to light. While this is not important for sketchbook work, if you wish to eventually display your portraits, ensure the ink is UV resistant. As a general guide, pigment inks will not fade with time while dye-based inks will. Just because something is waterproof does

From ubiquitous ballpoint to the finest fountain pen, pens and inks come in a bewildering array.

not mean it is not fugitive. Most drawing inks will fade, while Indian inks will not – both are waterproof. Fountain pen inks often act in beautiful ways when used to paint and draw; unfortunately many are fugitive (i.e. they will fade when exposed to light).

Pens

The array of pens available is extensive and we cannot review them all. Once bitten with the pen and wash bug, however, you are likely to accumulate a fair selection. From the ubiquitous ballpoint pen to specialist drawing implements, each has a different character and mark.

They can be split into two main types – reservoir and dip pens. A reservoir pen contains its own ink. They are convenient to use and possibly less messy. A dip pen is dipped into a bottle of ink, making it easy to change inks. Dip pens are less convenient but can be beautiful objects in their own right and bring great expression to your work. The choice is entirely yours, but fighting your materials is never fun so understanding what they can and cannot do helps.

Fineliners are a convenient reservoir pen containing pigment ink that is both lightfast and waterproof. You can even get refillable ones. They come in a variety of widths from 0.05mm to 1mm and are extensively used by artists who love line and wash because of their flexibility and availability. The examples in this chapter will use them.

Paper

Traditionally, pen and wash is carried out on a hot-press paper so that the fine lines are not interrupted by the surface texture. However, unless you plan to have very detailed ink work, I think a NOT surface brings much more to the mix. Finer pens may struggle on a rough surface. It is worth noting that ink and paper interact. Some inks that will be 100 per cent waterproof on certain papers will move slightly on others. Check your particular combination to make sure they behave themselves.

WASHES

The wash part of line and wash can be diluted ink rather than watercolour. Pans or tube watercolours are both perfect for the wash side of things. Some people like to use ink, Inktense or watercolour pencils washed out. The combination of the media offers lots of room for experimentation.

MARK-MAKING

Just how much detail you put into your line work is entirely a matter of personal taste. Some artists use ink for edges and contours, and like watercolour to build tone and modelling. Others like to build up tone with hatching, cross-hatching or other marks and end up tinting a fully rendered ink drawing.

Try This

Using a pen of your choice that produces a continuous line (so not a dip pen), create at least five different spheres. Do not outline the circles but create the shape and the tone by using different styles of marks. Now ask yourself which might be useful for creating a portrait? There is a lot more to a line than being straight!

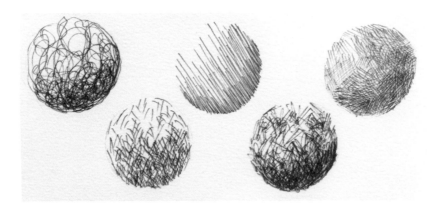

The ink work doesn't only have to define edges and contours; you can use it to add tone, and of course, lines don't have to be straight.

INK OR WATERCOLOUR FIRST?

One of the perennial questions in line and wash is 'which comes first?' This is entirely a matter of personal preference and it is always worth trying the same subject in both orders. Whichever you start with, it should be dry before switching media (*see* Rules of Pen and Wash) and I would suggest completing 90 per cent of the line or wash before switching, as it is easy to add more but not to remove if you have gone too far.

THE PORTRAIT

'What would happen if I painted a person in the way I would paint a building in an urban sketch?', was the question I posed myself. When I urban sketch, I usually start with broken lines, add washes of colour; then use brush pens to add tone; then add detail with lines and adjust colour. This may sound complicated, but it is a case of working in layers and letting the image develop without being too precious, as you never know when a lorry is going to park in front of your view. On the whole I tend to use a limited palette and improvise with colours when sketching outside, so I thought this approach might be fun in a portrait.

Materials
Black waterproof fineliners in 0.2mm, 0.5mm and 0.8mm provide the line work, while watercolours in Quinacridone Gold, Dioxazine Purple and Pyrrole Orange are used for the washes. Water-soluble dual-tip brush pens in a few shades of grey are used to rapidly add tone without re-wetting the paper.

First transfer the image in your preferred manner. Using a 0.2mm fineliner, mark in the contours and areas of significant tonal shift. Don't put in every strand of the amazing hair. Break lines as much as possible and avoid outlining every detail, especially around features such as the eyes and lips. I decided to outline the highlights on the cheek, nose and chin too, to slightly stylize the image. At this point, erase any unwanted pencil. Remember to stop at the 90 per cent waypoint.

Mix up large washes of watercolour. Quinacridone Gold and Dioxazine Purple combine to make a make a lovely rich brown, so you could have a puddle of this ready mixed too. Starting on the right side, use the 'growing a wash' technique, that is, using plenty of paint (you can see the reflections to see how wet the paper is), working in a continuous wash and changing the colour on your brush at each stroke to allow colours to mix and flow on the surface. Make sure to leave untouched areas of paper in the hair to indicate highlights.

You can paint the background, hair and face as one huge variegated wash. Be careful to keep the background less busy so it doesn't compete with the exuberance of hair. You can also keep

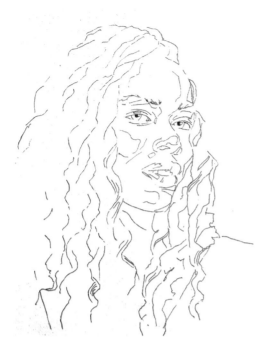

Broken lines help you avoid the temptation of creating a perfect drawing to be 'coloured-in'.

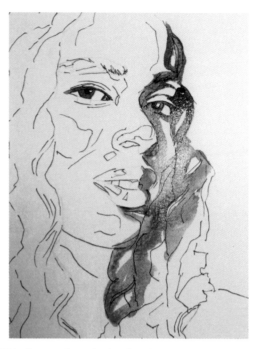

With all your paints mixed and ready to go, you can paint a large wash covering the face, hair and background.

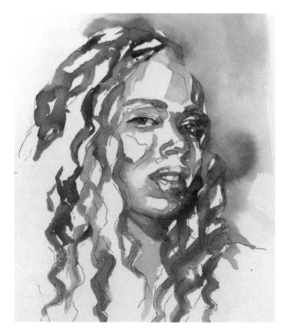

Leaving plenty of untouched paper lets the light sparkle through.

Dry brushing adds an element of texture to your otherwise flowing wash.

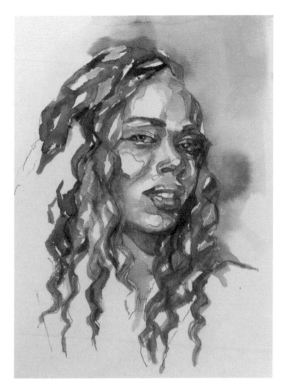

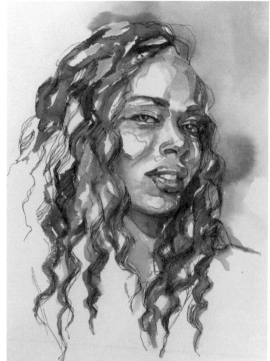

In urban sketching, watercolour brush pens are a quick way of adding tone without adding water. The same technique is used here.

Carefully consider whether further ink or colour is required to finish a painting. Stop too soon rather than too late, and avoid fiddling.

more untouched paper on the left to indicate that the light is coming from this direction. You do not need to paint inside the lines. This style succeeds where line and colour are both independent and complementary.

You could also drag a drier brush across the paper in places to add a small element of texture.

Once fully dry, use dark-grey brush pens to darken the shadow areas to the right, add a medium-grey shadow in the hair to the left and use a pale grey to add tone in the face. No drying time is needed for brush pens but be aware they are water-soluble, so if you decided to add more colour there is a danger they will dissolve and move around.

Now is the time to assess and decide whether further line or colour is needed to balance things. As the subject's hair is her crowning glory, you may want to make more of it. I used 0.5mm and 0.8mm pens to indicate the ringlets

and their direction. I did this with a continuous flowing line and continued some of it onto untouched paper, which I felt hinted at the mass without spelling it out.

WORKING ON A TONED PAPER

You can see from the portrait sequence opposite that it looks quite harsh. Using a toned paper brings a coherence and depth to the painting. Strathmore Toned Tan or Toned Gray mixed-media paper would be perfect for this approach. It is a smooth, heavy paper that can take watercolour washes well without buckling. However, you cannot see through it with a light box for transfer and there would be no opportunity to lift the background colour to regain highlights. For this reason, I like to tone my own paper with a flat wash.

Having tinted and dried the paper, lines and contours can be inked in.

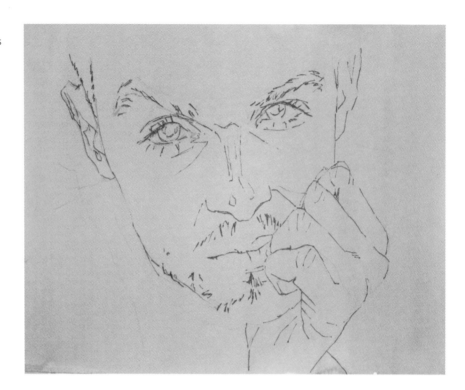

With all paints mixed and ready to go, the tonal map of the face can be painted in.Note how wet this is.

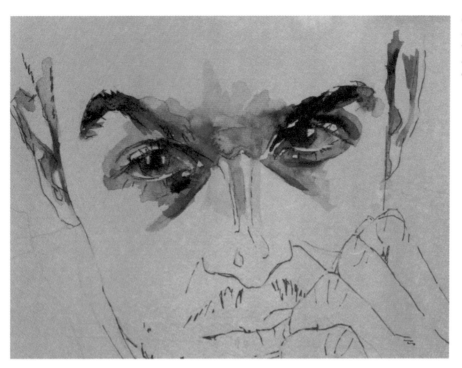

Concentrate on connecting areas wherever possible and give tone not colour the priority.

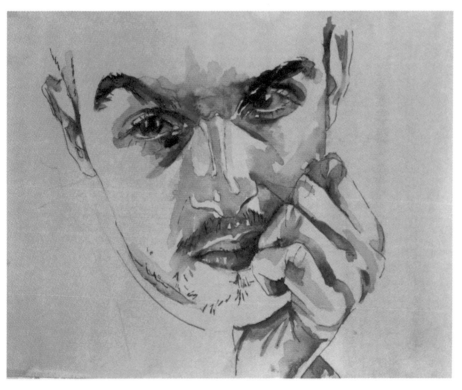

Continue working in big connected shapes down the face.

Hands add a lot of character to a portrait.

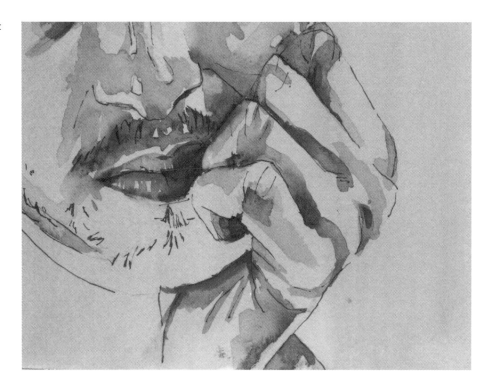

The beard is dark toned, but untouched areas of paper reveal the bristles.

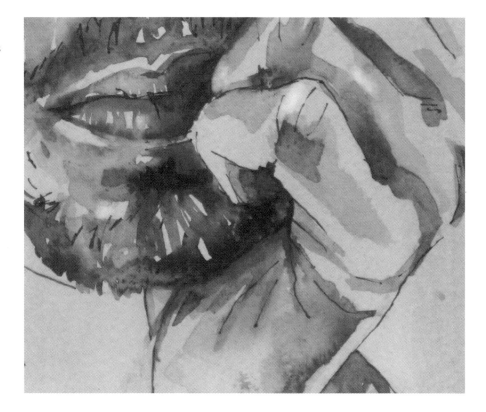

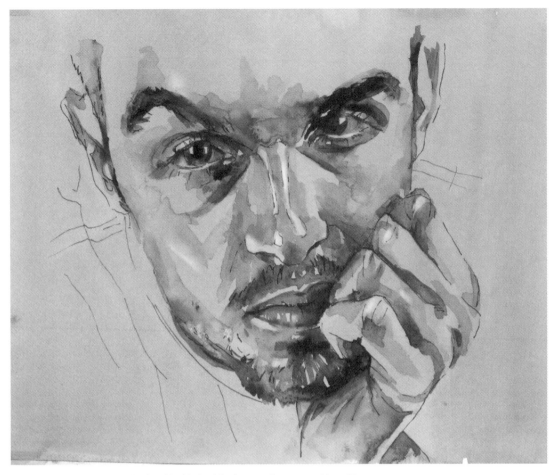

The clothing was left untouched and highlights lifted across the nose and knuckles.

Prepare your palette. I used Quinacridone Sienna, Quinacridone Gold, Sap Green, Perylene Maroon and Transparent Grey. I mixed a large thin wash of Perylene Maroon with a touch of Sienna to make a warm salmon colour. Do test it on a scrap of paper to ensure it is not too deep a tone and add more water if needed. Aim for it to be about a third of the way along an imaginary tonal strip – that is, a dark light tone or light midtone. With a large brush, apply as flat a wash as possible and allow to dry.

The image can be transferred in your preferred way. Using a 0.4mm fineliner, mark in the main contours, only putting in a few hairs in the eyebrows and beard. Ink in the outer edges of the highlights, making sure to break lines and keep them flowing. Erase any surplus pencil lines.

With the washes mixed and ready, the fun begins. Paying very close attention to the tonal map of the face and using the paper surface as your lightest midtone, start to add colour. Starting on the right eye, I noted how the dark of the brow joins with the dark of the eyelid and iris, so painted them as one continuous shape.

Concentrate on getting all the darks and midtones in place, leaving the lightest toned areas untouched and continuing to the left eye, growing the wash as it travels across. Put in the

shadow across the white of the eyes, leaving highlights on the iris and eyelid. I was tempted to leave the portrait at this point, with just the eyes staring at us from over the top of the hand. Sometimes leaving areas unresolved really concentrates you on the parts that are painted. However, I pressed on.

Working down the face, leaving the highlights on the nose, join the washes of the nose, mouth and chin, varying the colour and tone as you go. I put less of the cooler green into the hand as it was in full light and I wanted to bring it forward.

Make sure the beard is shadowed under the hand, but you can also leave small touches of dry paper to indicate bristles.

Let everything dry thoroughly while you assess which areas need to be darkened, highlighted or softened. In the end, I decided it only needed a few lines of pen to indicate clothing to allow the focus to be fully on those brooding eyes.

You could take a damp flat brush and 'tickle' the knuckles and highlights on the nose, then use kitchen towel to lift away the pigment you have loosened. Enough should come away to give you the highlights you need. They are not the white of the paper, but they are close enough because of the contrast. Of course, you could add in an opaque white if needed, as we shall see in the next chapter.

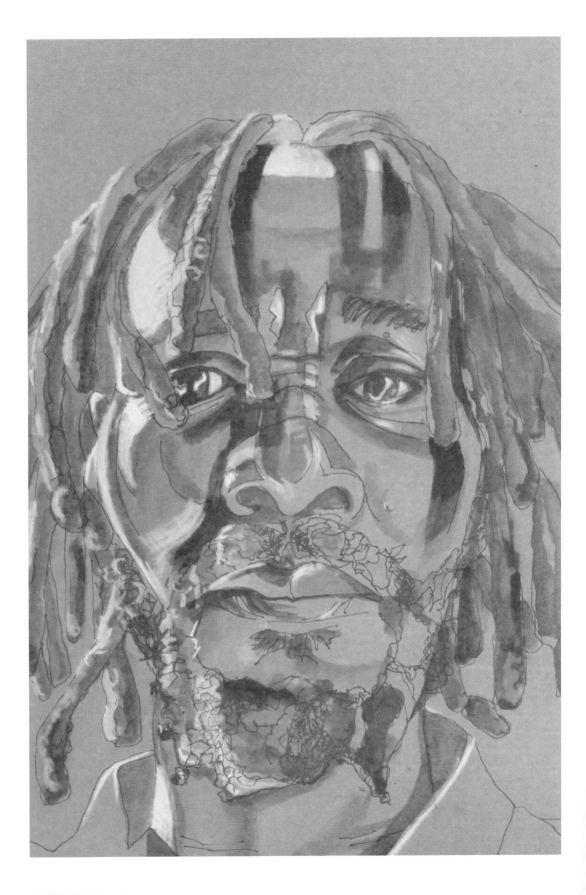

WATERCOLOUR PLUS – MIXED MEDIA

We started by using pure watercolour to capture the likeness and character of our muses. In the previous chapter we ventured into the world of mixed media with pen and wash portraits. Watercolour is sometimes thought of as a rather restricted medium. Mention mixed media and our thoughts often turn to acrylics. However, watercolour combines successfully with all sorts of other media, such as pastels, collage or ink, to give the adventurous artist plenty of scope for exploration.

RESCUING A FAILURE

If you are not happy with a portrait, you have nothing to lose by trying to rescue it with a second or third medium. Should you have lost definition through extensive use of wet in wet and soft edges, perhaps the addition of calligraphic lines using charcoal or ink might be enough to give punch to the piece. If you have lost highlights or you want to tone down something overly bright, adding an opaque media such as gouache or pastels may save the day. If it is beyond saving, then make sure you identify what went wrong to avoid repeating the mistake in the future.

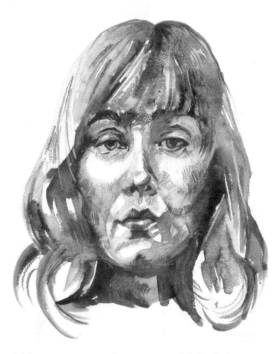

Adding an opaque media can rescue a failed painting.

Ink, watercolour, pastel pencil and a tinted paper make a wonderful combination for a portrait.

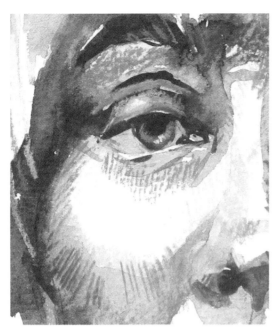

Opaque pastels helped unify and subdue an overly colourful portrait.

USE INK AS WATERCOLOUR

Ink is not just for pens; you can paint with it, dilute it with water and mix it with other inks. You need to be aware that it may be permanent once dry, but apart from that you can use it in the same way as watercolour. Drawing inks often behave beautifully in wet-in-wet applications, forming stunning organic marks.

COLLAGE

One of my favourite ways of mixing things up is to use collage in my paintings. While it is probably better to start a painting knowing that it will be collaged, realistically a failed painting might be rescued through additions or could be ripped/cut and used as a collaging material.

Watercolour and collage is a vast subject with endless possible combinations of media and techniques. Personally I like to use paper and text. Other artists are fans of adding found

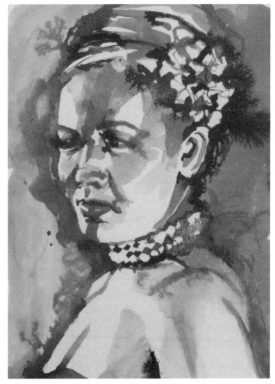

Inks can be diluted and painted in the same way as watercolour.

Used wet in wet, drawing inks produce amazing organic marks.

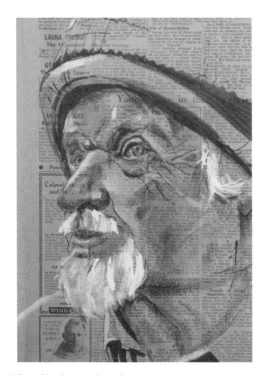

Collaged backgrounds, such as text or music, are interesting to work on, although lights need to be added with an opaque media.

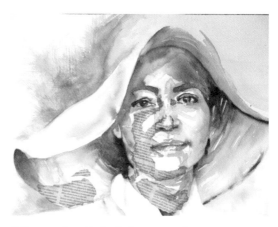

Collage can be added to indicate areas of tone.

objects – the preference is entirely personal. Here are a few thoughts to get you started.

- Add a background that has a connection to the main painted image.
- Working on an old book, maps or a music score may add an extra dimension to your work, either due to the pattern of the print or the connection to the concept you wish to communicate.
- Choose a shape or part of the composition to be collaged with paper.
- Add text to reinforce an underlying concept, perhaps adding collage from a countryside magazine to a portrait of someone who loves hill walking.
- Use watercolour to colour and pattern papers, which are then torn or cut and put back together to form the image.
- Use thicker collage pieces or objects to bring a three-dimensional quality to an essentially two-dimensional piece.
- Collage can introduce real texture to highlight particular areas, for example painting over a background of tissue paper.

GLUE

While the glue needs to be strong enough to bind the surfaces, you do not want it to add bulk

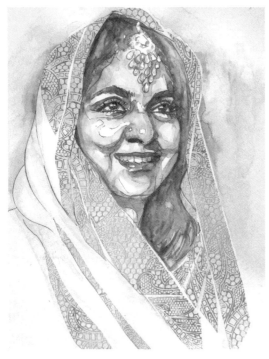

A beautiful sari was indicated using foiled paper.

and weight. Watered-down polyvinyl acetate (PVA) is usually strong enough to stick most papers. It will appear white when wet, but dry clear and colourless. There are water-soluble PVA glues, so check on this so that your creation does not fall to pieces if you plan to use multiple washes over your collage.

As a rule of thumb, apply glue to the heaviest paper; this will help to protect thin, delicate papers.

WATERCOLOUR GROUND

Certain papers may repel your watercolours. You will find that inks and acrylics adhere better to shiny or resistant papers. An alternative solution would be to use transparent watercolour ground. This will allow the colour or pattern to remain visible but will allow you to flow watercolour seamlessly over the surface.

Watercolour ground will also fill in gaps and unify the surface. One layer of white watercolour ground is not fully opaque, so can be useful to knock back an overly dominant pattern or can be applied in one specific area rather than over the entire surface.

A LITTLE COLLAGING FUN

I wanted to add a collaged element to this elderly face, as it struck me as one that had seen history being made.

Transfer the outline contours to the watercolour paper. Rip newspaper into shapes corresponding with areas of midtone. It is tempting to think that newspaper is a light tone, but when you look, it is relatively dark. A torn edge feels very different to a ripped one, so choose carefully when using. Note that newspaper, because of the acids it contains, yellows with time. It darkens when wet, which can throw your perception in the painting process. I used a glue stick to attach the pieces.

The tone of your collage paper can be misleading so judge it carefully.

You can paint over the collage to integrate it into the image.

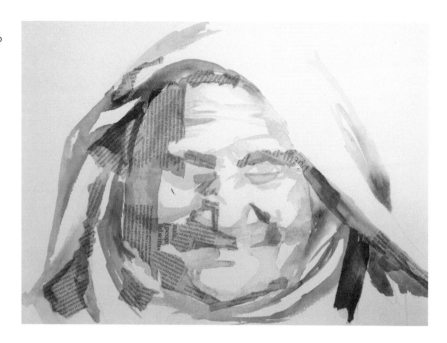

Darks and detail add a punch.

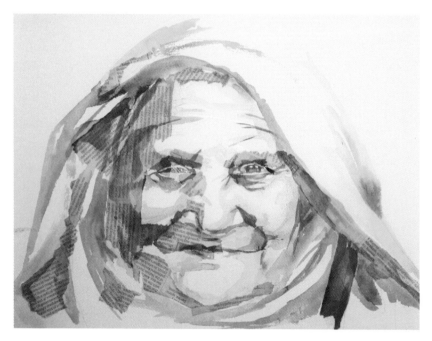

As the collage dries, mix up washes of Quinacridone Gold, Perylene Maroon, Prussian Blue and Burnt Umber. Apply these to the midtone areas, aiming to link as many shapes as possible and painting straight over the collaged areas, bearing in mind the colour shift already outlined. Paint the clothing at the same time in a very simplified form.

Once dry, you can apply deeper mixes of the same colours in a second layer to develop detail. I didn't paint every wrinkle in, just enough to show her age. I carefully noted the disparity in

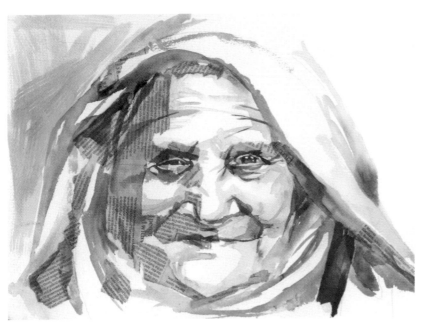

The background defines some of the head, but the rest is left with lost edges.

the eye size and that there was only a twinkle in the right eye. Shadows under the scarf were deepened too.

Finally, brush a dirty mix of the scarf colour onto the background using a flat brush and deliberately leave brush marks. There are plenty of lost edges on the left to add a bit of interest to a simple portrait.

ADDING A THIRD MEDIA TO LINE AND WASH

Adding something new to a line and wash piece really takes it to the next level. You could add collage, as we have seen, or a dry media. Soft pastels, coloured pencils, oil pastels and charcoal are all interesting candidates. In this piece, I used pastel pencils to add highlights, further colour and movement.

Pastel pencils are a convenient and less dusty alternative to soft pastels. They can be sharpened to a fine point or used on their edge for a broader mark. Faber-Castell, Conté à Paris and Derwent are all excellent brands.

Once the wash on the paper is dry, you can ink in as many or as few lines as you desire. Stopping at 90 per cent done is always a good idea.

In contrast with soft pastels, pastel pencil should not be added in successive layers of colours but used as pure colours laid out in patchwork-fashion side by side – so as not to dull the shades. Pastel pencils are available in a bewildering range of colours, but Conté à Paris does a portrait set of six including a blue and vibrant pink, which is perfect for this portrait.

The first step, as always, is to identify the palette of colours. This chap in his flat cap felt pretty blue, so I selected Phthalo Blue, Sap Green, Perylene Maroon and Transparent Grey. I used fineliners in a variety of widths, from 0.2mm to 0.8mm, and used the Conté à Paris portrait set of pastel pencils (white, two yellows, orange, pink and blue).

Using a dilute wash of Phthalo Blue, tint the paper evenly and allow it to dry. Once dry, transfer the image and, using a 0.2mm fineliner, use broken and jagged lines to put in edges, contours and the beard. Do not aim to put in all details. With two further media to come, less is

more. I remove the line and am surprised that the eraser has lifted the tint in places. To use this to my advantage, I deliberately rub lighter areas to slightly model the face. If something unexpected happens, always embrace it and see if you can turn it to your advantage.

I regret putting in some of the weave of the hat but do not panic as the pastel pencil is opaque and can hide a multitude of sins.

With puddles of your selected colours mixed and ready to use, including a tan mix from Sap Green and Perylene Maroon, start in the shadow areas under the hat and grow the wash down the face, trying to vary the colour as much as possible and allowing each brush stroke to flow into the next.

Leave plenty of dry paper to give the highlighted areas of the face and beard, and continue in a similar way with the rest of the face and clothing. We are painting the darker midtones and shadows at this point, with the dry paper giving us lighter midtones; the pastels

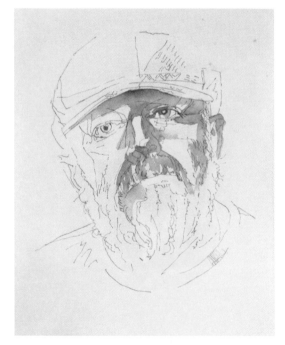

With your chosen colours mixed and ready to go, you can wash in the mid- and darker-toned areas, working wet up to wet.

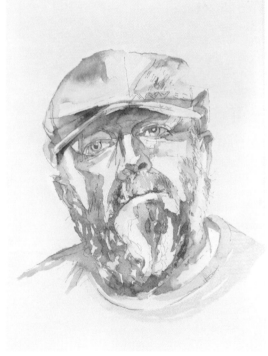

Continue over the rest of the face and clothing.

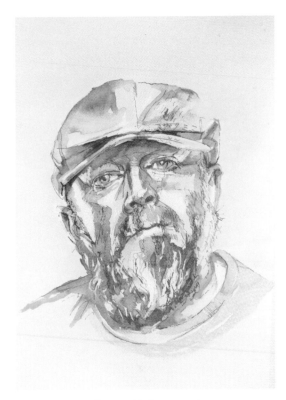

Make sure you are happy with the watercolour as you cannot add it on top of pastel without dissolving the chalk.

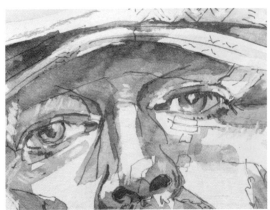

Hatching is a lovely way of adding pastel.

You may wish add more weight to some of the ink lines to balance against the pastel lines.

will be added later to give further lighter tones. All the areas are joined together and flow into each other. I don't soften the outside edges of the face.

The painting needs to totally dry and you need to be sure you do not want to add further wet colour before proceeding. If you wash over pastel pencil you will lose the marks as they dissolve into the watercolour. Add hatched lines to the face, trying to take into account the planes of the face and echo the direction of those planes. You can also add squiggles of colour into the beard and touch into the hat and shirt. I disguise the marks I do not like in the hat.

Again, take your time to consider finishing touches. I feel that a few heavier-weight ink lines would add variety so I use a thicker (0.8mm) pen to add a few marks in the beard, eye and left ear. I also use a thin wash of

Transparent Grey to darken only the top of the background, working around the head but bringing a little into the hat. I made sure no hard edge is formed by washing clean water over the lower half of the background at the same time.

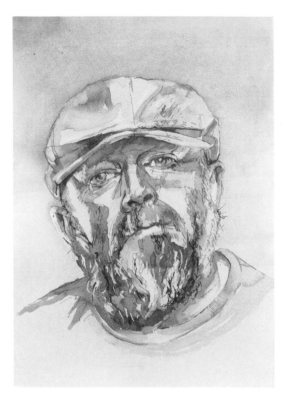

The background was darkened with a wash of grey to help the face stand out.

A NOTE ABOUT FIXATIVE

Pastel pencil will smudge if rubbed, so you may decide to use a fixative. If so, please test first as it can lead to a colour shift. Also spray outdoors as the solvents in the fixatives are noxious.

INK RESIST TECHNIQUE

This is a fascinating process that relies on gouache's ability to block waterproof ink from binding to the paper. It results in a woodblock print effect. The process must be followed exactly in order to work. Halfway through, your work will look a little like a 'painting by numbers' piece, but once you have revealed the image, it will have a unique charm and sophistication.

I personally don't think this is a great technique for child portraits, as you will inevitably end up with ink spots in unexpected places, which may spoil the smooth, line-free nature of a child's complexion

Ink resist is not for the faint-hearted. You will need to coat your entire painting in ink and then wash it under a tap. The end reveal is always a surprise – hopefully a pleasant surprise!

Materials

You will need gouache in appropriate colours. Gouache is also known as body colour, poster paint or even tempera (not to be confused with egg tempera). It is a water-medium paint consisting of a pigment, water, a binding agent and additional inert material. Gouache is effectively opaque watercolour. Acrylic gouache is something different and will not work for this process as it is waterproof once dry.

You will also need waterproof ink. Black Indian ink is usually used, though there is nothing stopping you using any colour ink you like, but it must be waterproof. You should select a robust watercolour paper that will stand up to being washed under running water. Note that some cheaper-quality papers may pill and disintegrate when wetted.

Test Your Materials

Always test your materials prior to embarking on a finished piece. Not only will this ensure no nasty surprises, it will also convince you that this process works.

Make a swatch of the colours you intend to use – small squares will suffice. Allow to dry thoroughly. Now brush the entire paper gently with a single layer of ink and allow to dry thoroughly. Rinse under a running tap, which will dissolve the gouache and leave behind a tint of the colours. If the paper falls to pieces, find a more robust one. If the colour washes away totally, understand you may need to touch up your work or select a different gouache.

Not all papers can withstand the rough treatment, and some gouache hardly leaves colour behind, so do test your materials.

The Portrait

Transfer your image to your paper. You can be bold with the pencil lines as these will be covered in ink. If you want a clean border, tape your paper down to a board.

Starting with white, apply gouache to any highlighted areas or others that you wish to remain white, which may include highlights on the nose, the whites of the eye, highlights on the lip, shine on the hair or the sparkle in the eye. Remember that any areas that are untouched by gouache will become black once the ink is applied. Then move to the scarf.

I find a small flat brush the easiest to apply gouache. You do not want to over-dilute the gouache, otherwise it will lose its ability to resist the ink. However, if it is too thick, you will struggle to obtain a sophisticated outcome.

The first colour you put down will be the final colour, so even if you blend and layer colours over the top, these will not show in the final piece. Apply colours in blocks, leaving unpainted areas to create the line detail. Do not worry if it looks childish at this point.

Now move on to the face and paint blocks of colour. You can overlap areas of colour if you do not want a black line to separate them. You will use far more intense colours than you finally desire as at least 50 per cent will wash away.

Start by painting any highlights white. Untouched paper, though it looks white, will end up black after the ink is applied.

Do refer back to your test swatches to gauge the likely outcome. Mix colours with white if you want the end result to be lighter than the swatches.

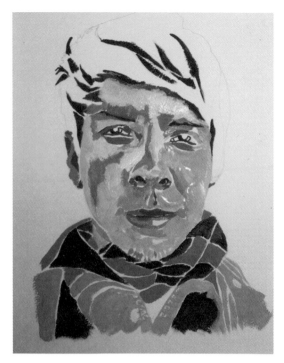

If you do not want black lines, paint a patchwork of gouache with no gaps between.

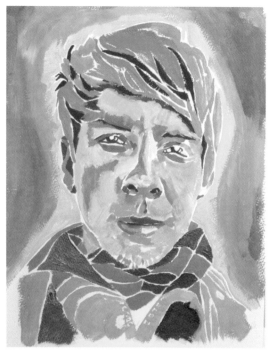

The first colour to touch the paper is the final colour, so blending can be difficult.

By holding your piece to the light, you should be able to see any uncoated areas and check that the paint is thick enough to partially block the light.

Move on to the hair and background. Getting smooth transitions of colour in the background will be next to impossible, unless you use tiny brush strokes. Ask yourself if that matters.

Dry the gouache thoroughly, otherwise it may dissolve. Overnight is best, especially if it is quite thick.

Now comes the scary part. It is worth taping your work to a board to avoid it bowing. You will also need to protect your work surface and remember you are using permanent ink.

Using a wide flat brush, gently coat the entire piece in a single layer of ink. Avoid working back and forwards as you will risk disturbing the gouache. There is a chance of the edges of each stroke showing in the final piece, so rather than painting the ink in stripes you might want to do shorter strokes in multiple directions.

At the end of the painting process it can look like a 'painting by numbers' picture, but do not fear.

Allow the ink to dry. You can use a hairdryer to speed up the process. Once fully dry, remove from the board and wash off under a running tap. Though you could use a bowl of warm water to dissolve the gouache, there is a danger of muddying up the white of the paper with dirty water.

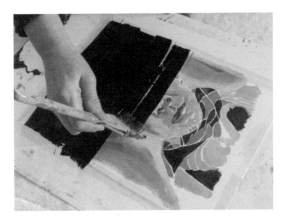

Once the gouache is bone dry, gently coat with waterproof Indian ink, taking care not to disturb the paint.

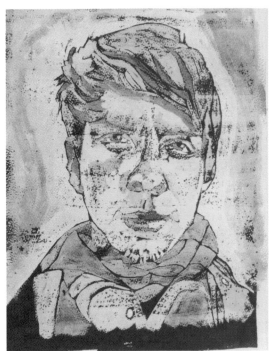

Once fully dry, you can assess whether adjustments should be made.

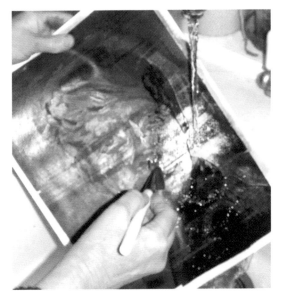

With the ink fully dry, the whole piece is washed under water.

Effectively, by dissolving the gouache you wash away surplus ink. The ink sticks to unpainted paper and in small places, leading to the woodblock look. You could use a brush to dislodge any stubborn ink but remember the more you wash it, the more colour you will remove. The colour of the gouache remains where it has sunk into the paper.

Allow to dry flat once you have removed enough ink and colour. Now assess the image.

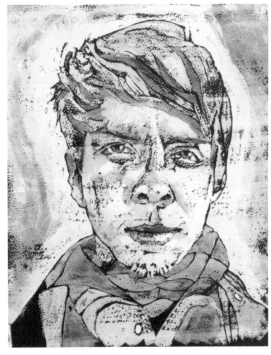

Watercolour can be washed on if too much gouache has been washed off.

You can adjust it, but you do not want to lose the charm of this process so ensure any additions echo the marks of the original piece.

If some ink remains over undissolved gouache, take a sharp scalpel and scrape it gently away. If you need to add further ink, a dip pen and ink can add pure black in a mark more in keeping with the process. Transparent watercolour can be washed over areas if colour needs strengthening.

Despite having tested my colours, I found that the brown washed off more than anticipated, so I had to strengthen the eyes, eyebrows and nostrils. The stripes of the scarf did not come out as expected, but I could live with that. Surprise is definitely part of this process.

You could, of course, do the entire portrait in black and white and then colour the painting once the gouache is washed off. The washing process removes much of the paper sizing, so you may find that watercolour sinks into the surface unevenly.

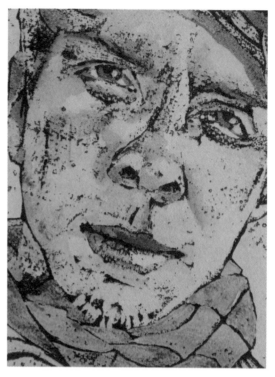

Further ink can be added, but it is important to match the marks of the wash-off technique.

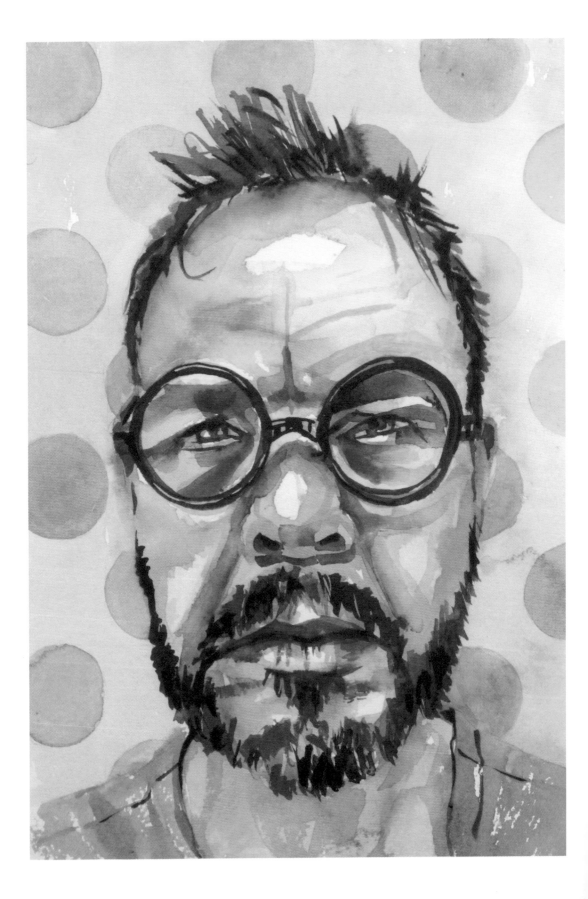

SPECIAL CHALLENGES AND HOW TO TACKLE THEM

Throughout this book we have used models of different ages and races, to try to cover as many permutations of the human face as possible. However, there are particular features that always present a challenge and are worth a closer look.

AGE

Our faces change with age, so if you are struggling with a face looking too old or too young, check the following.

- Features lose definition.
- The nose may become more bulbous.
- Ear lobes lengthen, making the ears look larger.

- Flesh drops and thins, especially around the jaw and neck.
- Lips lose fullness, eventually becoming little more than lines.
- Deep creases and wrinkles form.
- Hair thins, including eyebrows.
- Temples deepen and the eye socket becomes more evident.

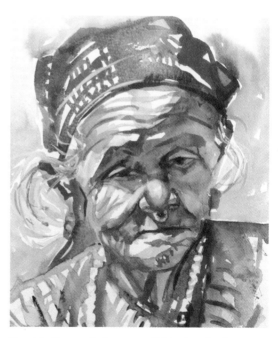

The older face can be far more satisfying to paint than a younger one, with every line telling a story.

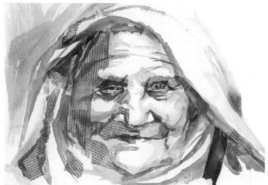

Ripped newspaper added areas of midtone to this face.

The quirks and foibles of each face mean that portrait painting is endlessly fascinating.

ATTIRE

Although this book concentrates on the face, you may want to paint more than the head, so what should the subject wear and how should it be treated? Clothing will say a lot about the character of the subject. It may also frame the face and help the composition. However, just as with background, we don't want clothes to dominate.

High-fashion attire will be frozen in time and the painting may date quickly. Something neutral is often recommended. White is a classic that never goes out of style and reflects light beautifully onto the face. Wearing white on top will also make the subject stand out from the background. However, if your subject is a fashionista and would not be seen dead in something neutral, that says a lot about them. You could always sketch two different versions of the portrait to help the subject see what a difference clothing makes.

Given that we don't want the clothes to wear the person, a more spontaneous painting technique hinting at the details is probably sufficient. Alternatively you could make a feature of it by collaging clothing (see the sari in Chapter 6) and going down the mixed-media route.

Clothing is part of the story you tell with your painting. A casual lumberjack shirt says something different from a collar and tie.

A similar simplified approach should be taken to jewellery and other accessories, so that they do not overpower the wearer.

BACKGROUND

The focus of any portrait is of course the face. However, you may wish to add a background for compositional reasons or to add further hints at the character and interests of the sitter. *See also the diamond background used behind a monochrome study in Chapter 2.*

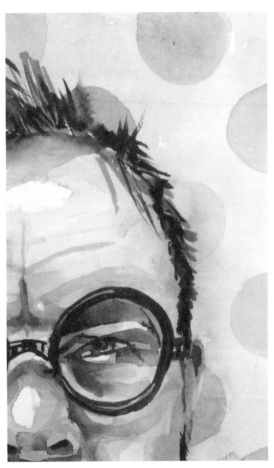

A background can make all the difference to a straightforward study, in this case echoing the glasses.

Always plan the background at the beginning, rather than finishing the face and then considering it. Given that the style of the portraits in this book are loose and lively, it is assumed that the background will not be in huge detail. It is often best to address the background first or at the same time as the first layer of the face. It is important that they are integrated. Colours in the background will be reflected in the face.

Working on the background first means that elements such as hair will overlap and the background will glimpse through, making it more believable and integrated. A pattern in a background can be all that is needed to transform a portrait.

BEARDS

Just as with hair, don't paint every whisker and avoid it looking like a comedy false beard. For a sparse beard, a shift in tone might be all that is required. You are likely to see detail at the edges, rather than in the middle. Soft edges can create the feeling of volume. The colour of the skin shows through the beard and it can be a great opportunity to introduce touches of colour from elsewhere in the painting.

BEAUTY

The 'curse of the beautiful woman' is real for portrait painters; I am sure there is the equivalent of the handsome man. Truth be told, perfect faces are both intimidating and a bit boring to paint. Smooth skin shows up faults in your painting technique and symmetrical features show any inconsistencies. Perfection can be bland. Faces with experience and imperfections are infinitely more fun and interesting. As faces become older and less perfect, they become more interesting to paint and easier, so search out inner beauty and avoid practising by painting celebrity photos.

CHILDREN

Painting a child's face is particularly challenging; it is so easy to age them. Their features are not defined like adults, due to their unformed bones. The shifts in value on the skin are subtle. Of course, a child's face has very different proportions to that of an adult, as we will see in Chapter 8. The skin is often unblemished and the whites of the eyes take on a blueish tinge. If you have inadvertently aged your portrait, check the length to width of the face and the positioning of the eyes.

If you want to have smooth tones to give a fresh innocent feel, avoid rough paper and consider where you place hard edges. Consider whether pen and wash is right for your subject. A heavy line achieved with a dip pen might overwhelm delicate features.

In any watercolour portrait, less is more – for a child's portrait even more so. Concentrate on their large eyes and their smile; all other detail is pretty immaterial. You are likely to be working from photos, given that most children

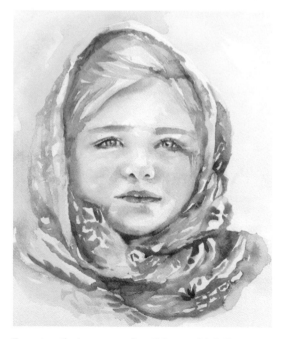

To capture the innocence of youth is a special challenge.

can't sit still. Don't use a flash and aim for gentle natural light from the side. You are likely to be taller than the child, so try to get onto their level and avoid distortions.

DETAIL

Our brain loves to fill in blanks, so leaving some areas unresolved adds to the interest of a piece. The eyes will probably be the focal point of the portrait, so anything else can be less finished. For example, you can leave the forehead merely hinted at.

EARS

Ears are strange too. As we don't find them that interesting, we tend to paint them smaller than we should and place them too high, resulting

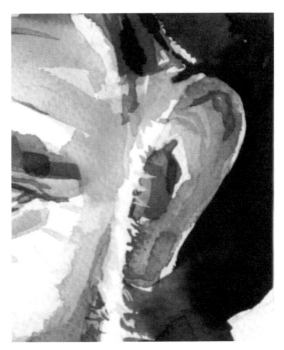

Ears are often painted too small and in the wrong place. They start at the eye line, rising to the brow and finishing in line with the nose.

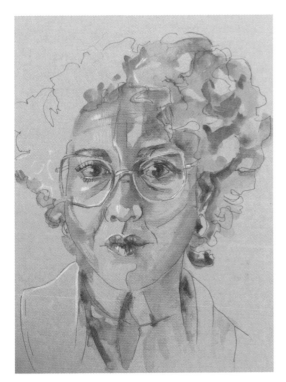

Leaving something to the imagination can be highly effective.

Bizarre as it may seem, the left ear is my favourite part of this mixed-media portrait from Chapter 6.

in the 'Shrek' look. In a profile view, they are easy to locate at the junction of the jaw and cheekbone. Ears seem to get larger as we age; certainly lobes elongate. The outer shape of the ear is not the same as the inner fold.

While it may be tempting to cover them up, try not to leave them out – we need all our senses.

EYES

A cliché for sure, but yes, the eyes are the window to the soul. They are great fun to paint but hold a few pitfalls for the unwary.

The biggest mistake is in the placement of the eyes. In adults they are halfway down the head, in children even lower. There is usually an eye width between eyes in the head-on view. Eyeballs really are balls, so they have shadows and volume. They are set into the skull, so are often in deep shadow. They are moist

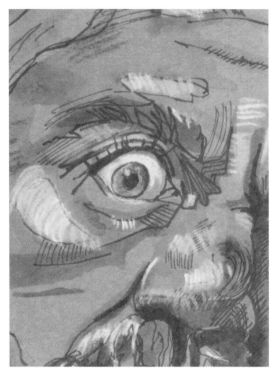

If you can see most of the iris, the subject may well be expressing extreme surprise!

It is fair to say that the whites of the eyes are rarely white.

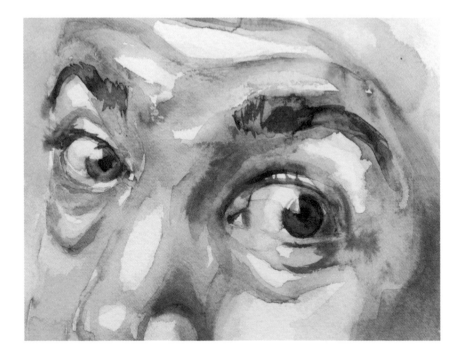

and therefore have complex reflections and highlights.

The whites of the eyes are rarely white. Instead, there are a mix of colours, shadows and reflections. The only time you will see white is in the reflected highlight in the eye, but not all eyes have highlights, so if you cannot see one do not paint one in. If you lose this small sparkle it is easy to regain. You can add a touch of white gouache or use an opaque white pen. A third method is to ensure the paper is bone dry and then take a sharp scalpel. You can lift a notch of paper out and reveal the white beneath.

With eyes, there is usually a shadow under the lid, so make sure that the top part of the eye is darker than the bottom. The outer edge of the iris is often as dark as the pupil. In an older eye, the whites of the eyes are often darker as they are set deeper into the eye socket.

Remember that eyelids work like lips. Eyelashes rarely need to be painted in individually. If you do, note that they are curved not straight; the top lashes dip before going up. Straight lashes look like sunrays and very cartoonish.

Consider how much of the iris you can see; only in a startled expression will you see it in its entirety. Otherwise the top and probably the bottom will be obscured by the eyelids. To place the iris correctly, it is far easier to draw the two triangles of the whites of the eyes – so draw the negative space around the iris, not the iris itself.

Be aware that depending on the tilt of the head, the eyes will follow a curve around the skull, rather than being in a straight line.

EYEBROWS

In their natural state, eyebrows follow the eye socket and give an interesting angle and indication of where the cheekbone starts. Follow the end down to the outer edge of the face and this is where the cheekbone starts. You might wish to emphasize this angle. Don't make them too dark or paint every hair.

FEATURES HAVE PERSPECTIVE TOO

The three-quarter view of the face is probably one of the most interesting to paint, however many people struggle with proportions. The key is to realize that features obey the law of perspective too. The eye closest to you will be bigger than the one further away; the half of the lip closest to you will be fuller than the furthest half. It is so obvious once you see it, but it took me ages to work it out! Also note how the features curve around the face and don't go in straight lines.

GLASSES

Glasses are great for anchoring the features and giving structure to the face. They often distort tones, and reflections can obscure the eyes. It may be best to underplay this. Note how the edges of the face are distorted by the lenses. This small detail will make them more believable.

HAIR

The temptation to paint each strand of hair can be overwhelming. Painting it as a single mass with lighter and darker tones can give the suggestion of individual hairs. Keep strokes as fluid as possible to give the hair a natural appearance. Add on a few smaller details. Take the opportunity for soft edges.

One way to avoid hair looking like a wig is to take your underpainting over the hair and face to integrate both. Observe that the hairline is not a hard edge; it is likely irregular and soft. By softening it we can avoid helmet hair!

Features follow the rules of perspective as they curve round the face.

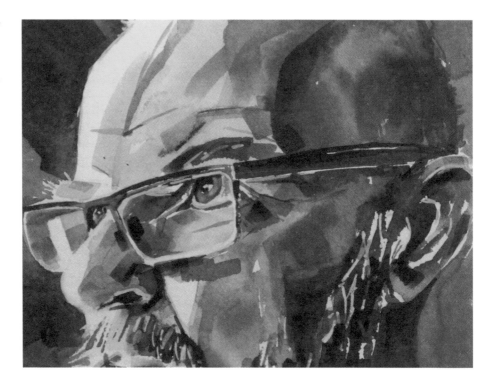

It is up to you whether you edit out the reflection and distortion of glasses.

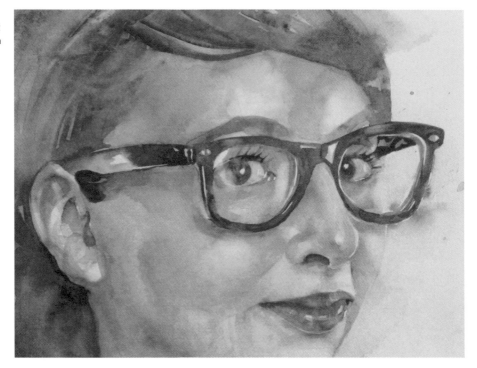

The colours in hair are often deeper tones of those found in the face. By using a common palette you will get a more integrated look.

HANDS

Second only to faces, we are all so familiar with hands that we tend to assume we know exactly what they look like. Because we see our hands every day, we make many assumptions when drawing them, hence they end up looking like a bunch of bananas. However, it is lovely to include hands in a portrait; after all, we touch our faces twenty-three times an hour according to scientists.

Hands are most successful when you paint the overall shape rather than a collection of five fingers, so squint to see this. Try looking at and painting the negative spaces between the fingers and not the fingers themselves.

Hands are much bigger in relation to the body than we assume. Place your hand on your face and you may be surprised at the size. The length of an adult hand equals three-quarters the height of the head and the wrist is usually just a little narrower than the palm.

Hands can possess a multitude of colours that may not always be expected. Interesting colours can be found in fingers that are backlit, allowing the artist to see blood colours shining through, or reflections from neighbouring clothing.

MOUTHS

'A portrait is a painting with something wrong with the mouth,' is the often quoted comment

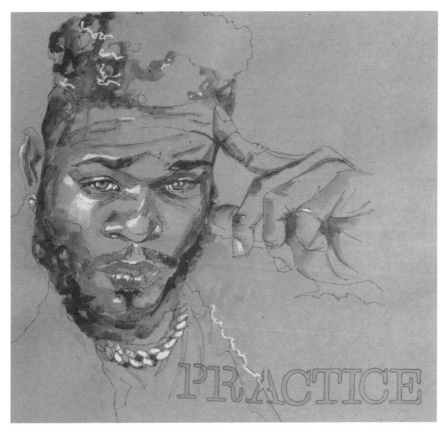

Hands have as much character as faces, so they can be fantastic to include.

Working from either the centre line out, or the mouth space out, will help render a mouth successfully.

Mouths really are quite peculiar.

by John Singer Sargent. A small detail will completely change the expression.

A few pointers will put you on the right track.

- The mouth curves around the face, it is not flat.
- The upper lip is usually wider and more shadowed than the lower lip. The lower lip protrudes and tends to catch the light; the upper lip curves inwards and is in shadow.
- The lower lip is often more defined by the shadow under it than by tone on the lip itself.
- There tends not to be a harsh line between lips and the surrounding skin, especially in older faces. Lips lose fullness and definition with age. If the line is hard, it will look unnatural and as if the subject is wearing lipstick.
- The corners of the mouth tend to be in dark shadow.

To get the mouth and expression correct, start by drawing the centre line where the lips meet and work out. If the mouth is open, start with the opening.

NOSES

Noses are odd, it cannot be denied. If you identify that they have four planes, it will help you avoid the snout look. The bottom of the nose is one eye width, and the edges of the nostrils are straight down from the tear ducts. As the face tilts you will be able to see more or less of the nostrils. The nose has a plentiful blood supply so is often a red and warm coloured area.

Avoid harsh edges to the nose. There may be a hard edge on the far side of the nose in a three-quarter view, but there will not be one on the near side edge and no hard edges in the face-on view. Putting in hard edges will immediately give a cartoon look. Be particularly careful in pen and wash portraits.

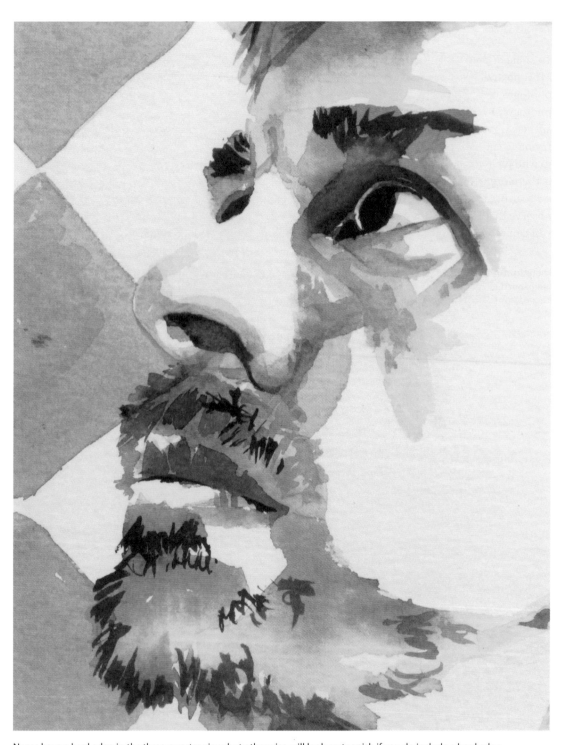

Noses have a hard edge in the three-quarter view, but otherwise will look cartoonish if you do include a hard edge.

TEETH

To smile or not to smile is the question. Most portraits do not show a smile, yet photographers encourage a cheesy grin. Before photography, maintaining a smile for multiple sittings was not possible. However, we are trying to capture the sitter's personality, and maybe their smile is part of them. The decision is therefore yours.

To avoid teeth looking like tombstones, observe that they are rarely white; squint and you can rarely see divisions. They are often in deep shadow and veer to the yellow. Treating the teeth as one surface (almost like a gum shield) will be more successful. Perhaps the small visible triangles of gums are all that is needed to indicate separate teeth. Try to lose edges wherever possible.

Teeth, like eyes, are not pure white and are reflective. Flesh tones work on teeth. Children may be the exception to this, as their teeth are whiter; if they are secondary teeth, they are larger and more prominent in their face. Again, observation will guide you, but underplaying is the way to go.

Many artists avoid teeth, but they can be great fun.

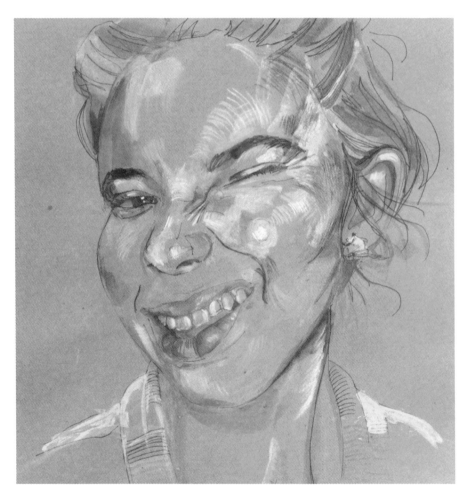

- Use a brush slightly larger than is comfortable for the area. Move to a smaller one only when you really need to. Don't try to cover a large area with a tiny brush.
- Remember, it is only a piece of paper and you are painting for enjoyment.
- Tone and patterns are more important than colour and detail.
- Look for large connected areas of tone and build in layers. Don't smooth too much (more in a child than an adult). Someone said to think of breaking down the major value changes in the face like creating a stencil – excellent advice.

- Let watercolour be watercolour. Allow it to flow and mix on the paper and accept cauliflowers, blooms and odd edges. This will keep your work fresh and avoid much frustration.
- Don't paint individual features. Instead, consider how they are all connected.
- Use warm and cool colours and realize that there is no such thing as flesh colour. Look hard to see the blues, greens and purples.
- Stop too soon rather than too late.
- Paint what you see, not what you know.

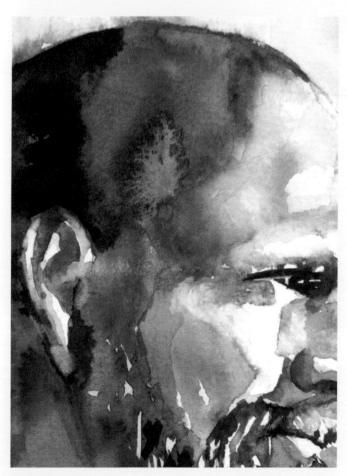

Embracing the chaos of watercolour, with its blooms and strange drying patterns, can add an excitement and energy to your portraits.

WRINKLES

Wrinkles show our age and experience, so they should not be shied away from, but equally hundreds of wrinkles might distract from the character and over-age the subject, so editing some out may be a wise decision. A little edit may lead to a truer likeness.

Wrinkles are effectively folds in the skin and treating them like fabric is not a bad way to think. Wrinkles follow form – they do not go in straight lines – so will curve across the forehead, for example. Treat them like painting tree branches and they will look far more natural. Be aware that they can cross over and intersect.

Observation is key. Depending where the light is coming from, the lightest area on a wrinkle may be underneath rather than on top.

ZONES

The face can be divided into three colour zones, which are especially obvious in pale skins. While I am not suggesting you paint your portrait in stripes, it is worth looking out for and understanding them. You might wish to hint at the zones in a painting.

The forehead is bony and well lit, and this can give it a yellow hue. The mid zone has a higher blood supply and will be redder – think about red in eyes, nose and cheeks. The lower half of the face tends to be in shadow, so will be cooler and bluer. These zones may be especially obvious among men, when the six o'clock shadow can appear pretty blue.

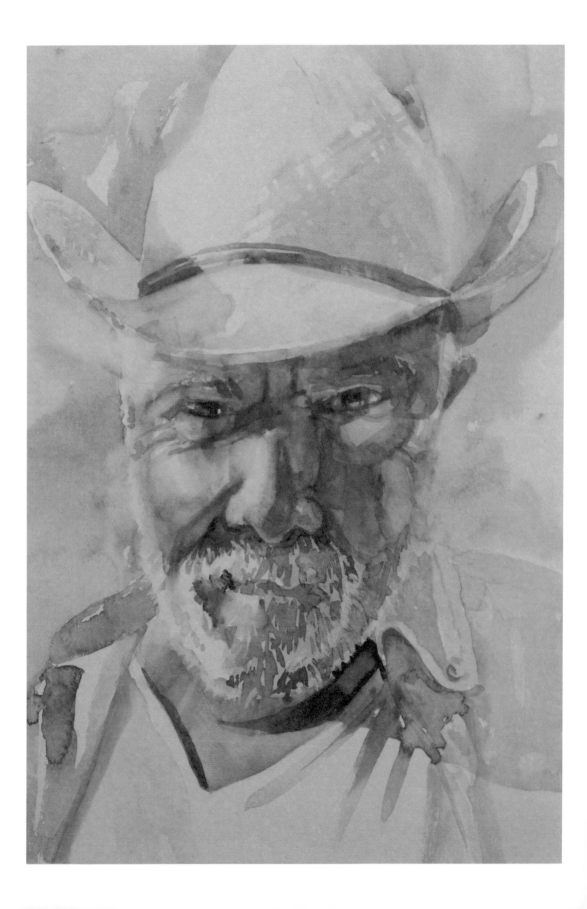

ACHIEVING A LIKENESS WHEN DRAWING PORTRAITS

Drawing and painting are two different skill sets – both exciting and wonderful, but to a large extent independent of each other. In watercolour, because of the transparency of the medium, the accuracy of the drawing is key. In most other media you can readily adjust as you go; sadly this is more limited in watercolour.

There is no shortcut or magic answer to be able to attain a likeness. The pursuit of it is, however, immensely satisfying. Tiny adjustments (often a few millimetres) will make a huge difference.

Hopefully by the time you get to this chapter you are buoyed up by success. You know you can paint a portrait, so now it is time to see if you can capture a likeness without using transfer methods. Don't worry if you struggle. The truth is that many successful professionals continue to use transfer methods throughout their careers, so should you wish to paint and not draw, then please do so without guilt.

THE CHALLENGE

Drawing is a muscle that needs to be regularly exercised. In learning to draw any subject there are two main challenges. First, to master hand-eye coordination – to get your hand to do what you tell it to do. Second, to learn to really see what is in front of you.

Using upside-down drawing, negative space and even upside-down painting can make for exciting portraits.

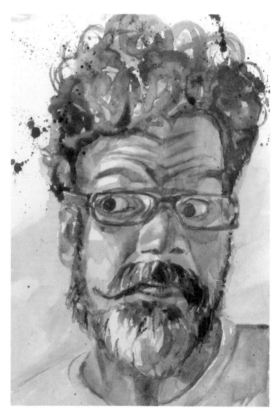

Although I regularly draw upside down, it had never occurred to me to paint upside down. It was a revelation.

Our judgement is coloured by decades of experience and knowledge. Our brain overrides the evidence of our eyes. To really see and understand what is in front of us is far harder

than you think. We need to learn to believe what we see, not see what we believe.

You will probably start to draw from photos unless you have very willing family and friends. Because the photo has flattened the image for you already into a two-dimensional form, you will find it easier. However, always try to imagine you are drawing from a real person who may move at any time, so that your drawing has life and energy.

If you have not yet had a go at the drawing exercises in Chapter 1, do revisit them as they will increase the strength of your drawing muscles if used regularly.

SIGHT-SIZE

When we draw, we are trying to flatten the three-dimensional world onto two-dimensional paper. As noted, it is easiest to start your

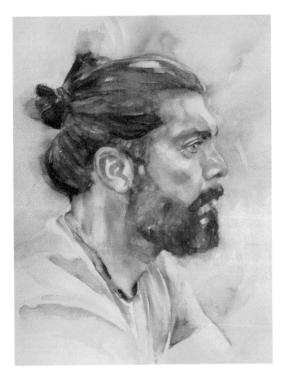

Understanding some basic proportions and anatomy can help you render the head convincingly. A purple underpainting added a glow to this portrait.

freehand drawing journey from photos as they are already flattened. When you move to live subjects, always shut one eye to help see in mono, rather than stereo.

Sight-size refers to a method in which the artist makes a drawing the same height as the subject being rendered. This allows the artist to see their subject and drawing side by side, directly comparable, with both appearing the same size.

Site-sizing has many benefits. You can make objective comparisons of size, shape and proportions. With your print right next to your paper, you can quickly dart your eyes back and forth from the image to the drawing, which makes it much easier to see differences.

If you are working from a reference photo, print it out to the exact same size that you wish your painting to be. Ensure it is in the same plane as your drawing board, not propped up. You can now draw like-for-like. To check, flick your eyes backwards and forwards between the reference and the drawing. You will retain a shadow of each and superimpose them to be able to see where things are off. You can even physically check by placing the reference behind the drawing and using a bright window or light box. This should work up to 300gsm/140lb paper.

When working from a model, position yourself at a distance from the subject that allows the exact same size of drawing. Have your paper in the same plane as the subject, so it will need an easel to be vertical. Now work in the same way.

WARM UP

Just as you might warm up before exercising, try one of the drawing exercises from Chapter 1 before jumping into a portrait. Spend five or ten minutes doing a continuous line drawing with a pen or marker to help you get to know the subject more intimately.

Scrutinize your subject – what makes them stand out? Kind eyes, a long nose, a crooked smile? Look carefully and consider how it differs from perfection.

- Warm your hand up with a five- or ten-minute version of your subject.
- Start with big shapes and move to smaller.
- The structure of the head is more important than the features, so don't get caught up in details (especially the eye) before making sure the skull and neck are in place.
- Establish hair early on. It has mass and is connected to the head.
- Understand the eye socket and the shadows it casts.
- Work from the centre out. The tendency is to work from eyes down, but this can amplify mistakes. A better way may be to work from the nose out.
- The cheekbone, ear and jawbone meet at one point, so this should help with placement.
- Look at the features relative to others; measure and consider the standard measurements given later in this chapter.
- Check angles by holding your pencil against features or imagine the face of a clock and measure the angle by its hands.

Tiny changes can make a huge difference, so it is worth taking time to get the drawing right rather than thinking it is close enough. However, do not over detail your drawing. You need to leave space for spontaneity in your painting process.

ANATOMY

Drawing a skull helps you consider shapes under the surface. Much of it can't be seen in the face but understanding the jaw and eye socket in particular will help you make sense of what you are seeing. There are free apps aimed at medical students that allow you to see a skull from any angle (*see* Further Resources).

A basic understanding of anatomy will really help, especially around the eye socket and cheekbone.

THE STANDARD FACE

Very few of us have perfect faces but understanding standard proportions both helps us believe what we see and gives us something to check against if things seem off. Remember no face is symmetrical. Even standard proportions are not agreed, so you will find slight variations in descriptions. The classic text is *Drawing the Head and Hands*, by Andrew Loomis, so much so that the 'Loomis method' is the closest we have to an agreed format.

The proportions of an adult head differ from those of a child, male and female proportions vary slightly and race impacts proportions. Female faces are generally smaller, with less-prominent brows, noses and chins. The width of the neck is also crucial. Simply altering the neck can make a face more masculine or feminine.

The standard proportions are straightforward to learn and if superimposed on a face will show where it deviates.

STRAIGHT-ON PROPORTIONS

Start with a circle and divide it into quadrants; then draw a square within it touching the circle at its four corners. The top line of the square is the hairline, the midline is the brow and the bottom is the nose line. Find the chin by adding on another of the smaller squares. Now put in the jaw. With time you can just eyeball where the jaw is; every head starts with a ball and jaw.

To find the eyes, divide the head in half. It will obviously be just below the brow line. Divide the width of the eyeline by five. This is the size of the eye. There is one eye's width between the eyes. Put in the brows on the brow line.

A line from the inner corners of the eyes down to the nose line defines the width of the nose – the nose is an eye's width at the bottom. Draw in the iris and pupils. The width of the mouth is defined by a vertical line from the inner edge of the pupils.

Divide the nose-to-chin area in three and the mouth lies in the middle third. Alternatively, it can be split in two to give the bottom of the mouth.

The ears start at the eye line, rise up to the brow and finish at the nose line. The neck comes from the bottom of the ears. Remember that hair extends beyond the skull, so you can put in whatever style you want, taking into account the hairline you found earlier.

Try This

Find a head-on photo, perhaps one of the references we have already used, and map the perfect proportions onto it. How perfect is the face? Where does it differ?

PROFILE PROPORTIONS

In profile, you can start with the same circle and square, then put in the chin line. You need to add in a curve from brow to chin. The ear is located behind the midline, starting at the eye line, going up to the brow and finishing on the nose line. The nose starts between the eye and brow, while the mouth is set back in the middle

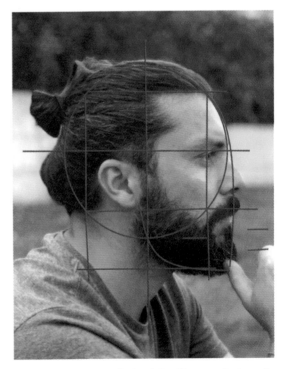

The head in profile can also be defined by a standard set of measurements, although of course we all vary a little from perfection.

third of the nose-to-chin area. The jaw goes from chin to ear.

We can see that our man in profile has a high brow and short nose in comparison to the perfect proportions.

Try This – Egg Head

What if the head is not in perfect profile or directly facing us? If it is in three-quarter view

If the head is viewed from below, the features will curve down.

Most guides suggest the perfect facial proportions but don't stress the curvature of the face.

or tilted, we need to understand the impact on the angles. Grab an egg and draw a few proportion lines on it, then start tilting. See how the features curve around the face as soon as it is not straight-on. Never forget that the head is a three-dimensional curved object.

CHILDREN'S FACES

Children are not just mini-adults. It can be hard to get children to look young enough and we have all seen portraits where the baby looks like a little old man, rather than a fresh-faced cherub.

If you look at the proportions of a child's face, it will soon become apparent that they differ significantly from those of an adult. A baby's face is proportionately much smaller than that of an adult, especially when compared to the size of their skull. Straight-on, a baby's face is only one-third the size of its skull, while an adult's is half the size of an adult skull. In profile, a baby's face occupies a quarter of the total head.

Given that children grow and change so quickly there is no one proportion guide. By the teen years, faces have pretty much the same

If tilted down, the features will curve up.

proportions as adults. The challenge is to really observe and look out for key differences.

- The brow is roughly at the halfway point, while the eyes are below the midway line.
- Setting the eyes in relation to the midline across the face is the direct way to establish the age of the child.
- If you divide the face into four from the brow, the bottom of the eyes, the nose, the corners of the mouth and the chin come close to falling on the lines.
- As the child grows, the face gets longer in proportion to the head. The nose and upper jaw appear to lengthen.
- The space between features is proportionately wider.
- The eyes are wider apart.
- The space from eye to ear appears wide.
- A young mouth is more pursed when relaxed; the upper lip usually protrudes.
- The chin is not a reliable point for measurement because most babies have chubby chins or even double chins. It is certainly small.
- Cheeks are full.

Babies grow fast, we all know, and while the overall length of the head grows, the face grows more in proportion to the rest of the head.

GETTING THINGS IN THE RIGHT PLACE

It is better to get the overall location and proportions of features correct first and not get caught up in their detail. Tiny differences can really change the way the face looks.

Checking angles between features also helps, for example:

- The angle between the inner corner of the eye to the outer edge of the nostril.

- The angle between the outer edge of the eye and the outer edge of the mouth.
- The angle from the corner of each eye to the end of the nose.
- The angle between the centres of the eyes and the end of the nose is an equilateral triangle in the perfect face.
- The hairline to the eyebrow, the eyebrow to the underside of the nose, and from the underside of the nose to the chin are almost exactly the same – the face is split into thirds.
- In a profile, the distance from the corner of the eye to the jawline and from the corner of the eye to the back of the ear is usually the same.

Use negative-space shapes to help you judge the relationships between things. This can be especially useful in drawing the eye. The temptation is to draw the iris too large. If instead you draw the two triangles of white, you automatically place the iris in the right place and at the right size.

WAYS TO SPOT MISTAKES

When drawing and painting a portrait, it is easy to know that there is a problem but far harder to pin down exactly what it is. Try any of these techniques to help you see.

- Turn the reference and drawing upside down – compare them.
- Take a photo. The act of looking on your phone screen helps you see it with fresh eyes.
- Look at the painting in a mirror.
- Walk away and rest your eyes.
- Ask someone else – they do not know what was going on in your head, so will see things with fresh eyes.
- Look at it from a different perspective. Prop the drawing up so that you catch a glimpse of it as you go about your business.

- A person's eyes are always halfway up their head.
- The eyebrow is above the halfway point of the head – except in children, when the features are lower.
- The hairline to the eyebrow, the eyebrow to the underside of the nose, and from the underside of the nose to the chin are almost exactly the same – the face is split into thirds.
- The tops of ears are usually roughly in line with the eyebrow, starting at the eye line, the lobe with the bottom of the nose. As people age, their ears get larger and the lobes elongate.
- Looking straight at you, the corners of the subject's mouth line up vertically with their pupils.
- The tear duct is vertically aligned with the outer edge of the nose.
- There is an eye's width between the eyes.
- The underside of the bottom lip usually falls halfway between the underside of the nose and the chin.
- The iris is round but will become oval as it turns from you.
- Use the head as a measuring tool for the rest of the figure in a full-body portrait. Most people are about seven to eight heads tall.

PRACTISE, PRACTISE, PRACTISE

Above all, practise consistently and frequently. Consider joining one of the thirty-day challenges available on the internet. Drawing a face a day and sharing your work will transform the way you draw. Just as you would be a lot fitter if you went for a jog every day for a month, you can take your drawing for a workout for thirty days and see how far you have come.

UPSIDE-DOWN DRAWING AND PAINTING

An exercise from the classic book *Drawing on the Right Side of the Brain* by Betty Edwards suggests putting your reference photo upside down. This stops you seeing what you are drawing as a face; instead it is a series of shapes and tones. We can take this further by painting upside down.

If you wish, turn the reference photo black and white and posterize it, to group areas of similar tone together. This makes it far easier to connect areas and shapes. Eventually you will be able to judge this without needing to take this step, but for now it is a good training tool.

Ensure that the paper you intend to use is the exact same proportion as your reference image. The way to do this is to place the lower left corner of both reference and paper together. Run a diagonal straight line through

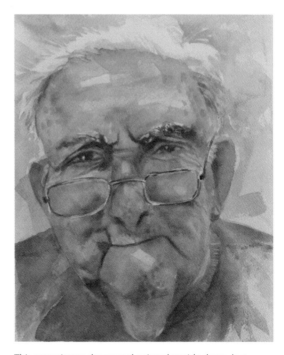

This portrait was drawn and painted upside down, but because my paper was not in direct proportion to my reference image, the face is too broad.

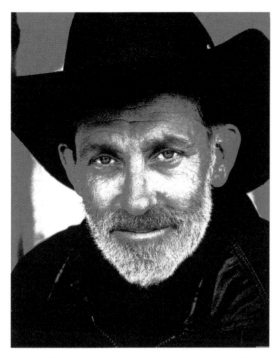

To make life easier, you can turn your reference image black and white and use the posterize function on your photo-editing software. This will simplify it into areas of similar tone.

the reference corners. Where it hits the edge of the paper gives you dimensions in the same proportion. If you do not do this you will end up distorting the face. If this is one of the first times you have tried a freehand likeness, make life easier for yourself and have your reference and paper the same size.

Now turn your reference upside down and place it alongside your sheet of watercolour paper. It should be in the same plane as your paper to make your life easier and to make comparisons more obvious. Start with the negative space around the head. These abstract shapes will be easy to copy and will define the volume of the head.

Now work on the main shapes and contours, before moving on to smaller shapes and details. Put in enough to ensure good placement of the features, but not so much that it constrains you. Try to keep lines light and flowing and avoid excessive erasing as this will damage the surface of your paper.

Ensure that your paper is exactly the same proportion as your reference, otherwise you will distort the image.

Start by drawing the negative space in each corner. Using the negative shapes as anchors, you can now put in the major shapes and contours, indicated in red.

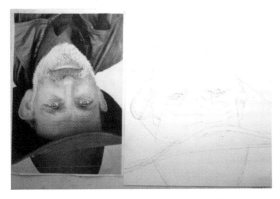

Continue working from large shapes to smaller. If your image is identical in size to your reference, you can flick your eyes between them to check on sizing.

Place the reference and drawing side by side and flick your eyes backwards and forwards between the two to work out any discrepancies. You can physically measure if you need to. Look at some of the angles outlined previously (*see* Getting Things in the Right Place) to check. If you are feeling brave, do not turn your drawing the right way up. You will spoil the surprise.

Select and check your colours. I suggest doing it now after the drawing, as it will also give your eyes time to rest; when you go back to your work, you may spot mistakes with fresh eyes. I used Quinacridone Gold, Perylene Maroon, Sap Green, Transparent Grey, Phthalo Blue, Quinacridone Red and some white gouache. Payne's Grey would be a good alternative, especially if it were a blue version. Make sure you have some large creamy washes mixed up so that you don't need to stop and mix in the middle of your work.

Avoiding the highlighted areas across the nose and cheek, and also most of the beard, use a large wash of Sap Green and Perylene Maroon mixed to a tan. This is the lightest toned area; you can drop in a slightly stronger mix into areas that are a darker value and also continue out into the hat to connect everything. This large slight shadow area will underpin the rest of the painting so make it as large as possible and connect as many areas as you can. Note how the skin shows through the short beard in places.

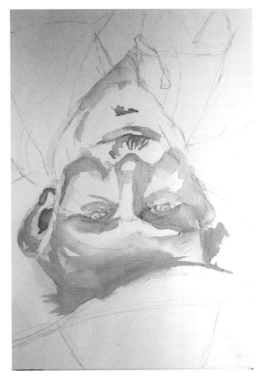

Continue working upside down and apply a large wash of your lightest tone, retaining highlighted areas.

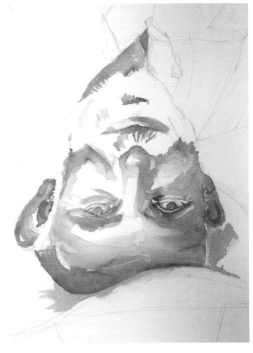

Allow the first layer to dry and work a second wet-in-wet layer.

Allow to dry and then layer on some Quinacridone Gold where the skin is more yellow. Working wet in wet with more of the green-maroon mix, start to develop the midtone areas. You will see why posterizing your reference is such a help. Start to develop the eye area too. Try to leave the glint in the eyes untouched, but don't panic if you lose it. You will be able to regain the highlight later.

Once this layer is dry, continue to deepen the shadows, noting the shadow under the hat, in the eye socket and the neck area.

Again once dry you can work on the hat and clothing. Note that there is a soft edge between the hair and the hat. Keep the details of the clothing loose, so that they do not distract from his face.

The moment of truth. Once dry, turn your painting around. I hope you will be pleasantly surprised. Now assess what works and what

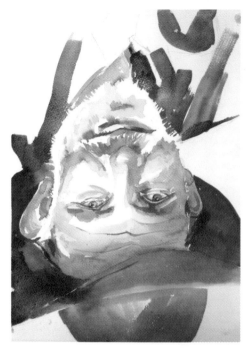

Using darkest values, work on the hat and clothing, though keeping it simple so as not to detract from the face.

Now deepen shadows in a third layer and work on finer details of features such as the eyes.

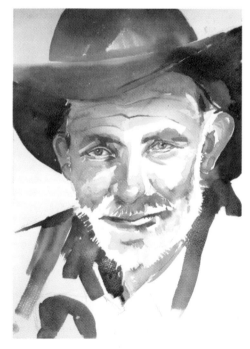

It's time to rotate the painting and assess its strengths and weaknesses.

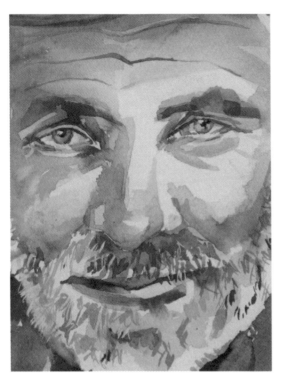

Adjust your work, but avoid the temptation to fiddle.

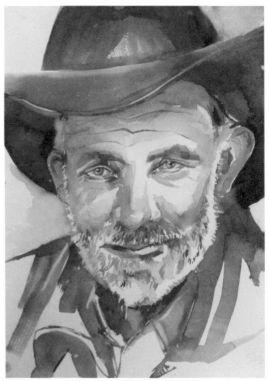

Upside-down drawing and painting should result in a surprisingly accurate rendition of your muse.

doesn't. The beard needs more work and everything needs a bit of impact. I achieve this by introducing more red around the eyes and into the beard. Do you recall the zones of colour? This face subtly follows those, with yellow across the forehead, more red in the middle zone and blues coming into the beard.

I decide a light background wash will help negatively paint the edge of the beard. A little gouache will also add more texture. I have a fiddle with the shape of the subject's hat before putting my brush down.

LIST OF REFERENCES USED IN THIS BOOK

All photos used in this book are taken from Pixabay. This site showcases millions of royalty-free photos. It is free to use. However, photos may be removed by their owners, so although these are available at the time of publication, please be aware their removal is beyond the author's control. Many alternatives of a similar nature will be present to allow you to apply the demonstrated techniques.

Chapter 1
https://pixabay.com/photos/
woman-girl-model-pose-portrait-4130596/
https://pixabay.com/photos/
model-woman-hijab-beach-muslim-5630849/

Chapter 2
https://pixabay.com/photos/
model-woman-hijab-beach-muslim-5630849/
https://pixabay.com/photos/
woman-girl-model-pose-portrait-4130596/
https://pixabay.com/photos/
grandpa-old-man-old-age-beard-hat-1855015/

Chapter 3
https://pixabay.com/photos/
face-shadow-light-darkness-dark-164512/
https://pixabay.com/photos/
dido-stargaze-man-face-model-6516904/

Chapter 4
https://pixabay.com/photos/
man-teenager-face-smile-hoodie-5989929/

https://pixabay.com/photos/
portrait-asian-girl-model-woman-5601950/

Chapter 5
https://pixabay.com/photos/
woman-portrait-african-american-1018284/
https://pixabay.com/photos/
young-man-staring-head-on-chin-1463299/

Chapter 6
https://pixabay.com/photos/
elderly-woman-old-elderly-5919192/
https://pixabay.com/photos/
man-cap-portrait-beard-hat-7354360/
https://pixabay.com/photos/
coney-island-nyc-new-york-boy-head-4488742/

Chapter 8
https://pixabay.com/photos/
man-tattoo-beard-hipster-tattoos-3841000/
https://pixabay.com/illustrations/
man-portrait-face-guy-male-black-7003423/
https://pixabay.com/photos/
people-cowboy-male-hat-person-875597/

ARTISTS TO ADMIRE

If you want to be inspired by contemporary watercolour portrait artists, why not take a look at the following:
Ali Cavanaugh www.alicavanaugh.com
Nick Runge www.nickrungeart.com
David Lobenberg www.lobenbergart.com
Carne Griffiths www.carnegriffiths.com
Dominic Beyeler www.dominicbeyeler.com
Florian Nicolle www.behance.net/neo_innov

FREE GRIDDING TOOLS

To quickly add an accurate grid to your reference photo as an aid to transfer or enlargement:
www.griddrawingtool.com
https://yomotherboard.com/add-grid-to-image/

FREE 3D SKULL

BoneBox – free app to allow you to rotate the skull to understand the underlying structure.

SKTCHY

If you have an iOS device (iPad or iPhone) you can download the Sktchy app for free. This is like Instagram for portrait artists. There is a huge variety of royalty-free images to inspire you and should you wish you can join in the daily challenge or share your resultant images with the very supportive online community of artists. Not to be confused with Sktchy Art School (school.sktchy.com), which has paid-for classes available.

SOURCES OF ROYALTY-FREE PHOTOS

www.pixabay.com
www.pexels.com
www.flickr.com
www.unsplash.com

PAINTMYPHOTO

PaintMyPhoto (PMP) is a social networking site dedicated to sharing photos for artistic inspiration, without fear of infringing photographer' copyright:
www.pmp-art.com

FURTHER READING

Edwards, B., *The New Drawing on the Right Side of the Brain* (HarperCollins, 2001)
Loomis, A., *Drawing the Head and Hands* (Titan Books, 2011)

To see more of the author's paintings, please visit www.lizchaderton.co.uk.

INDEX

background 19, 26, 38–39, 60, 71, 84–85
beard 29, 38–39, 53, 65–67, 75–76, 85, 105–107
brushes 19–20, 34–35, 94
children 35–37, 56, 85, 87, 93, 101, 103
cold pressed *see* NOT
collage 70–74
colour mixing 34, 45–47
colour wheel 33–34, 45, 51, 53
complementary colours 33, 46
drawing exercises 15–17, 98
dry brush 48, 55, 61
edges 21–22, 59, 85
eyes 85, 87–88, 99
fineliners 59
glasses 88–89
gouache 26, 29, 69, 77–81, 88, 105, 107
gridding 11–13, 109

grisaille 50–55
growing a wash 37
hair 10, 23, 25, 88–90, 99, 100, 102
hands 65, 90
hot press 24
ink 29, 34, 57–67, 69–71, 74–76, 77–81
layering 43–55
light box 13, 62, 98
line and wash 57–66, 74–77
materials 19
mixed media 7, 26, 57–66, 69–81
monochrome 19–26, 51
noses 91–92
NOT 19, 24, 59
paper 19, 24
pastel pencils 74–75
pens 57–67
photography 15, 37
Pixabay 106
posterizing 38, 48, 106

proportions 88, 98, 99–102
reference photos 14–15, 106
rough 24
sight size 98
skull 88, 99–101, 109
staining 29, 44–45, 48, 52, 53
standard proportions *See* proportions
swatching 20–21, 26, 31–32, 45, 53, 77–78
teeth 53, 92
tone 19–29, 31–32, 35–39, 46–47, 59–60, 94
toned paper 26–29, 62–67, 68, 74–77
tracing 11
transfer methods 9–14
upside down 97, 102, 103–107
value colour switching 31–39
wet in wet 20, 47, 58
wet on dry 20

DEDICATION

Thank you to all at The Crowood Press for their confidence in me as I tackled my fifth book. Much appreciation goes to my husband Ian, for his support throughout this process. Thank you to the artists on Museum by Sktchy who inspired me to start my portrait journey and who continue to amaze me with their vision and skills.

First published in 2023 by
The Crowood Press Ltd
Ramsbury, Marlborough
Wiltshire SN8 2HR

enquiries@crowood.com
www.crowood.com

This impression 2024

British Library Cataloguing-in-Publication Data
A catalogue record for this book is available from the British Library.

ISBN 978 0 7198 4281 8

Cover design by Nikki Ellis

Typeset by Envisage IT
Printed and bound in India by Parksons Graphics Pvt. Ltd.